T0277211

PARANORMAL
NORTHUMBERLAND

ROB KIRKUP

AMBERLEY

First published 2023

Amberley Publishing
The Hill, Stroud
Gloucestershire, GL5 4EP

www.amberley-books.com

Copyright © Rob Kirkup, 2023

The right of Rob Kirkup to be identified as the Author
of this work has been asserted in accordance with the
Copyrights, Designs and Patents Act 1988.

All rights reserved. No part of this book may be reprinted or reproduced
or utilised in any form or by any electronic, mechanical or other means,
now known or hereafter invented, including photocopying and recording,
or in any information storage or retrieval system, without the permission
in writing from the Publishers.

British Library Cataloguing in Publication Data.
A catalogue record for this book is available from the British Library.

ISBN 978 1 4456 9898 4 (print)
ISBN 978 1 4456 9899 1 (ebook)

Typesetting by SJmagic DESIGN SERVICES, India.
Printed in Great Britain.

Contents

Introduction

The county of Northumberland has been shaped by its rich and troubled history. The Romans were here, with Emperor Hadrian famously building a wall in AD 122, 73 miles long, east to west, which runs right through Northumberland. The Vikings arrived on the shores of Northumberland on 8 June 793, launching a bloody attack on Lindisfarne. This was the first major Viking raid on Britain. The Norman Conquest

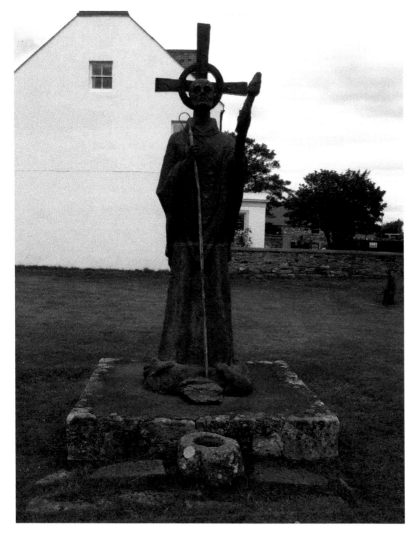

St Cuthbert of Lindisfarne.

in 1066 would leave its mark on the county, and the Anglo-Scottish wars throughout the fourteenth to sixteenth centuries would hit Northumberland particularly hard, due to being the most northern county in England.

Considering its bloody history, it's hardly surprising that Northumberland has more castles than any other county in England, and the greatest number of battle sites.

The turbulent past has left its mark on the landscape, not only in the form of the ruined castles, pele towers, and manor houses scattered across the county, but also in the shape of the phantoms and spectres that haunt every corner of Northumberland.

Just waiting to be explored in Northumberland is a castle considered by many to be the most haunted in all of Britain, a hotel that is home to over sixty individual ghosts, a stretch of beautiful beach where after dark disembodied hands crawl through the sand, and even woodland, surrounding a lake, that is believed to be home to the North East's very own bigfoot.

A part of the world as beautiful as it is terrifying, let's look at some of the scarier places to be found across Northumberland.

All photographs are by the author unless otherwise stated.

Castles

Northumberland has seventy castles, the most of any county in England. Most have seen unimaginable bloodshed and suffering, especially when you consider the constant threat of invasion they faced during the Anglo-Scottish wars, due to their close proximity to Scotland. Considering this, it's hardly surprising that many of these castles are believed to be home to restless spirits of a bygone age, and one in particular has earned notoriety the world over, for being one of the most haunted places on Earth.

Bamburgh Castle

Bamburgh Castle is an awesome sight on the north-eastern coast atop a massive rock. It dominates the Northumbrian coastline for miles around, and has done since the eleventh century. It is without doubt one of the most imposing castles left standing in Great Britain. It has been used in a number of films and television shows, most recently featuring in the latest *Indiana Jones* movie. Bamburgh Castle has been suggested as being the legendary Joyous Garde. Sir Thomas Malorey's fifteenth-century works *Morte D'Arthur* claims that Sir Lancelot's castle was right here, standing guard over the Northumberland.

There was probable Roman occupation here, followed by a previous sixth-century fortress on this very site. It was invaded by Vikings in AD 993 and then again in 1015, which left the previous castle destroyed, and Bamburgh Castle was built upon the site. When you consider the rich, yet bloody, history of this castle and the area, it comes as a little surprise to find that Bamburgh has a number of resident ghosts.

Bamburgh Castle's most famous ghost is that of the Green Lady. In the early fifteenth century, there was an impoverished family living in the area. Desperately in need of food, a young woman named Jane set out for the castle, with her baby, to beg for food. She pleaded to the castle guards, who kindly offered her into the castle grounds, but once she was inside, they changed and began to abuse her, refusing to allow her see the lord. They pushed her out of the castle grounds. Weak from hunger, she tripped and fell down the castle steps. She had been cradling her tiny baby, and both died in the fall.

Jane's ghost is seen wrapped in a green cloak, clutching a baby in her arms as she descends a staircase from a postern gate then she falls, accompanied by a scream. This horrific re-enactment can be seen from the large green in front of the castle, and horrified onlookers have rushed to this young lady's aid, but are unable to find any trace of her or her baby.

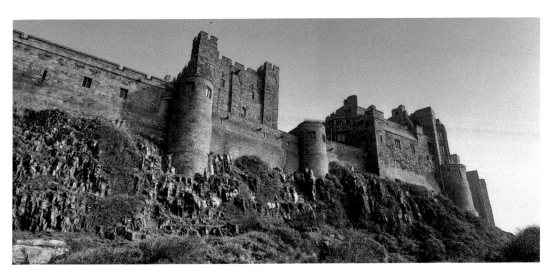

Above and below: Bamburgh Castle.

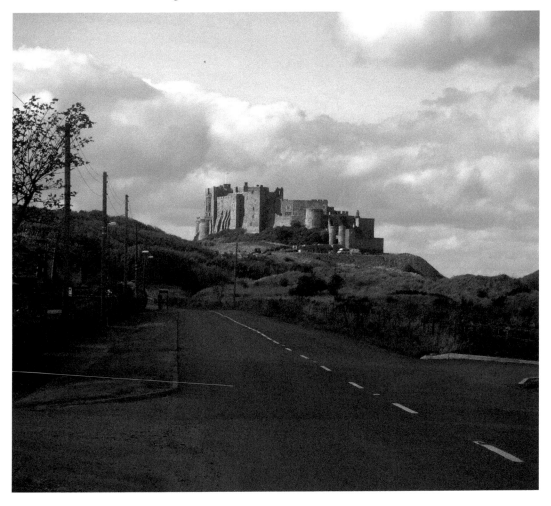

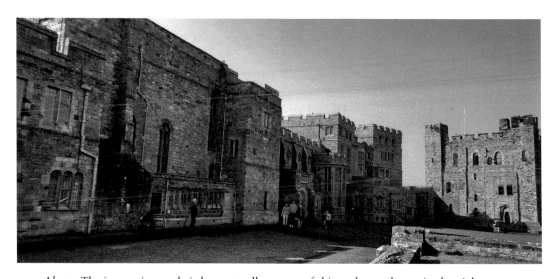

Above: The impressive castle is home to all manner of things that go bump in the night.

Below: The Green Lady is seen falling from people on the green here, in front of the castle.

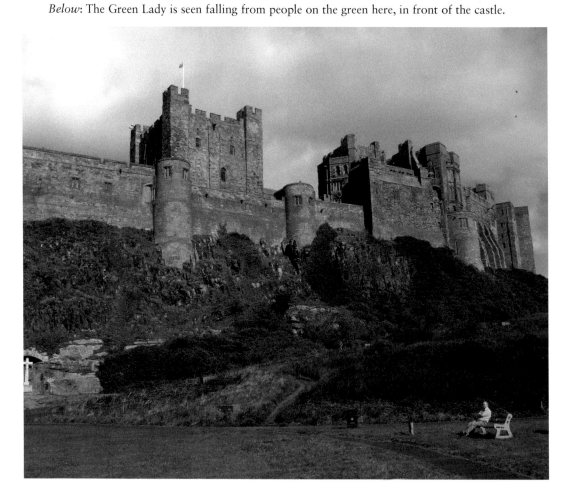

The Pink Lady is another tragic female spirit that resides at Bamburgh Castle, and dates from the times of the previous fortress on the site. In the early eighth century, a princess of the castle was deeply in love with a local man. Her father, the king, did not approve of his daughter's suitor and sent the young man overseas, with the strict instruction that he could not return for ten years. This was devastating news to them both, but they respected the king's wishes, and both made a promise that they would wait for one another, and when he returned to Bamburgh they would be wed.

After a long year, the king spoke with his daughter, telling her that he had terrible news. Word had reached him that the man had met another woman on his travels, and he had married her. The princess' world crashed around her in that instant. Being apart from her true love had been hard, but she was safe in the knowledge he would return to her, but now all hope had been ripped from her, and her heart was broken. In an effort to lift her spirits the king arranged for the castle seamstress to make her a beautiful new dress in her favourite colour – pink. Upon its completion her father presented it to her. She dressed herself and forced a smile, then excused herself, saying she needed some air. She walked out onto the castle battlements, and without a second thought she threw herself over to her death below.

Ten years after setting sail from Bamburgh, the man returned, bursting with excitement at the thought of seeing his beautiful princess. She had occupied his thoughts every waking moment since leaving her a decade earlier. He was unmarried.

The battlements from where the Pink Lady threw herself to her death.

Above and below: Disembodied hands are seen crawling through the sand at Bamburgh beach.

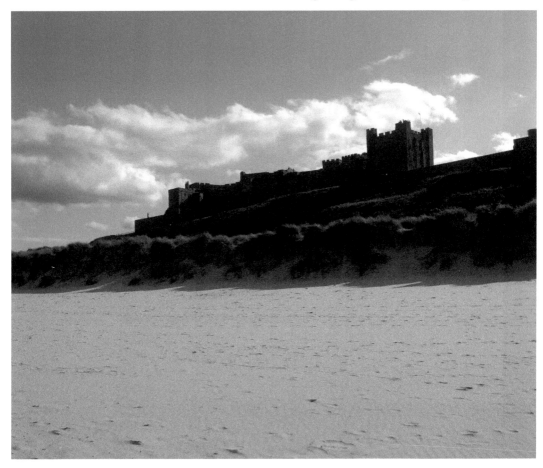

The Pink Lady walks the castle, appearing to walk through walls, following the route of the former castle, rather than the current Bamburgh Castle. She is seen walking down to the beach to await the return of her love.

The keep of the castle is the haunt of a medieval knight, clad in a full suit of armour. He has been seen patrolling the halls, accompanied by the clanking of his armour. The Armstrong and Aviation Artefacts Museum is home to a phantom Elizabethan naval gunner.

A piano has been heard playing in a room which is known to be empty, but the moment anyone enters, it stops. Ghostly children have been seen, running, laughing, and playing in the corridors.

The castle was restored in the eighteenth century by Dr John Sharp, and his spectral figure has been seen slowly walking around the castle, appearing to still be caring for the building in death.

In 2007 I spoke to castle staff and was told that there had been three sightings in that very same year of a tall, cloaked figure. On each occasion the figure was followed by a member of staff, who were keen to understand if the, apparently lost, visitor required help. However, on each occasion, the mysterious man would go through a door, or round a corner, and when the member of staff followed a second behind, they found that they had just vanished. The figure was seen twice in the King's Hall and once in the Cross Hall porch.

Archaeological excavations that were conducted between 1998 and 2007 revealed an Anglo-Saxon burial ground dating back 1,400 years, containing the remains of around 110 men, women, and children. This might offer an explanation for the terrifying encounters that have taken place on the sand dunes at beach at Bamburgh, mostly in the years before there was any awareness of bodies lying below the sand.

When Roman Polanski's *Macbeth* was being filmed at the castle, some extras were enjoying the beautiful beach at Bamburgh when they spotted something crawling through the sand. On closer inspection it was a dismembered human hand. They thought it was some kind of impressive special effect, but it quickly dawned on them that it wasn't.

In the 1980s a school trip visited Bamburgh, and after enjoying a tour of the castle, they headed down to the beach. A fog began to roll in from the sea, so the teacher told everyone to hold hands. A girl at the back of the human chain let out a scream. She had turned to see whose hands she was holding, and found that she was holding a hacked-off human hand, which vanished the moment she began to scream and cry for help.

There have also been dozens of reports of black shadows seen moving swiftly through the dunes.

Chillingham Castle

Chillingham Castle began life as a tower in the twelfth century and was improved and expanded through almost 800 years of constant occupation. That was to change in 1933, when it was abandoned and left empty. It was left unoccupied for decades, decaying, rotting, and being home to all manner of wildlife. In 1982 Sir Humphry

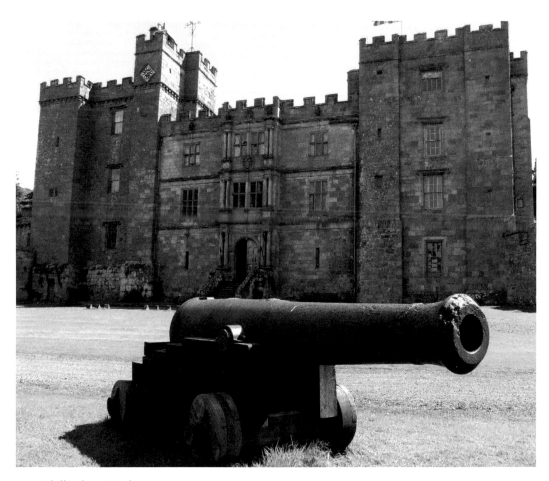

Chillingham Castle.

Wakefield and the Honourable Lady Wakefield took over the estate and set about the enormous task of restoring the castle to its former glory. In recent years Chillingham Castle has become infamous worldwide as one of the scariest places on Earth.

Too much blood has been shed at Chillingham Castle, and this ancient fortress has borne witness to some truly abhorrent acts. It's been written that the castle's torturer during the border wars, John Sage, ensured that this was the case. Sage first served his country on the battlefield, fighting against the Scots. He was one of King Edward I's best men, had worked his way up to the rank of lieutenant, was a fierce soldier, and merciless. However, he was cut down in his prime when a Scot caught him with a spear in battle, forcing it through his leg. He survived, but would walk with a limp forevermore, earning him the nickname of Dragfoot. He could no longer serve his country, as he had done with so much fervour, so Edward I handed him the role of Chillingham Castle's torturer.

John Sage absolutely revelled in this role. He was a brutal man. He hated the Scots and had no qualms about dealing out unimaginable pain or suffering, whether it be to a Scottish man, woman, or child. He used all manner of horrific torture devices,

The torture chamber.

even devising some of his own. He used barrels full of spikes that would have had someone tied into it, usually a child, and they'd be rolled around until the flesh was ripped from their body and they died due to loss of blood. He used a boiling pot, gadgets for gouging eyes out, and ripping out tongues. He even used an iron cage that was nailed to the prisoner's stomach and a starved rat placed inside. The only way for the rat to get out of the cage was to eat its way through the prisoner. John Sage was a cruel man, and he loved every second of it. He tortured upwards of fifty Scottish prisoners a week, and the pain and suffering they endured at his hands is unimaginable.

John Sage was castle torturer for three years, and the only risk to his position were times of peace, those times when England and Scotland called a halt to the warring between the two nations and there was no longer any need to take prisoners into Chillingham Castle.

On one of these occasions the king called for Sage to release all the Scottish prisoners, in a gesture to their Scottish neighbours just over the border. John Sage agreed, but had absolutely no intention of letting those being held in the castle reach their homes and families, as he knew they'd never forget what John Sage had done to them within those castle walls and would seek retribution. So he hatched a plan. Prior to the prisoners being released he got word to all of the local Northumbrian towns

and villages to let them know that the Scottish prisoners were to be released from the castle on a specific date and time.

The war may have been over, for now, but these locals had suffered at the hands of the Scots, due to their close proximity to the border. Some had been robbed, had their homes burnt down, and some had lost loved ones at the hand of Scottish invaders. So over 1,000 angry locals, armed with whatever weapon they could lay their hands on, made their way to the castle in advance of the prisoners being released, and hid in trees and bushes along the long pathway leading to the castle known as the Devil's Walk. Sage freed the Scottish men, women and children who were imprisoned at the castle. They were free, something they never expected to happen when they had been captured, such was Sage's reputation. However, the ecstasy of freedom turned to horror as the Scots, some only infants, were hacked to pieces before they'd even left the castle grounds.

The Devil's Walk.

These were troubled times, and peace didn't last long. So, upon the peace treaty being broken, John Sage went back to work, torturing and killing. But as quickly as war has broken out, peace was restored, and once again King Edward I sent word to the castle to release the prisoners. John Sage sent word back that this would be done, but he would once again betray the orders of his king. Instead, he rounded up all of the young children being held captive and marched them up to a room at the top of the castle, known today as the King Edward Room, as he stayed here in 1298. He then went out into the courtyard and built an enormous fire. When the fire was roaring and crackling, and the heat was at its most ferocious, he called for all of the remaining prisoners to be brought out into the courtyard. These were men, women, and the older children. They were placed one by one into the centre of the fire. The smell of burning flesh filled the castle grounds, and the screams of those being burnt alive will have been heard for miles around, before finally giving way to silence as the final prisoner perished.

The young children, some only toddlers, will have undoubtedly heard the screams of their parents and older brother and sisters, and would have been petrified, unsure of what was happening outside, or what was to happen to them. This would soon be answered, as John Sage made his way back up the staircase to the King Edward Room,

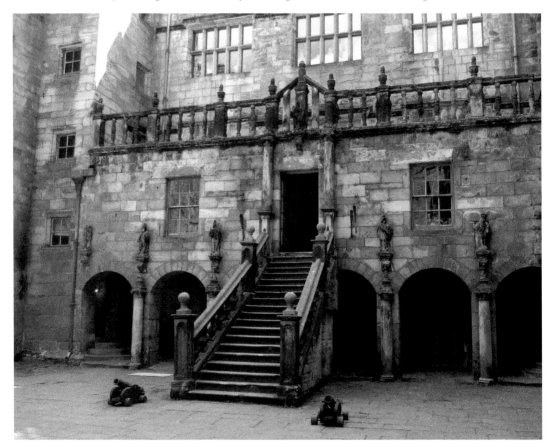

The courtyard with the entrance to the Great Hall.

picking up a razor-sharp axe on his way. He killed every one of those little children, right there in that room, hacking and slashing at them until the room was a mass of body parts and gore, and he was bathed in their blood.

Ironically, one of John Sage's torture devices proved to be his downfall. He had a girlfriend called Elizabeth Charlton, and one night they were having sex on the rack in the torture chamber, and he strangled Elizabeth to heighten her sexual pleasure. However, he took it too far and killed her. He was distraught, but this was only the beginning of Sage's problems. Elizabeth Charlton's father was the leader of the Charltons, one of the Border Reiver clans. He wanted Sage dead, and told King Edward I that unless John Sage was killed, the Border Reivers would ally with the Scots and invade Northumberland, and they would kill every single person they encountered. The king was penniless from the constant warring with Scotland and was left with no choice, for he knew they would make a formidable enemy and Northumberland would fall. The king sent word for John Sage to be executed.

An enormous crowd turned up to witness John Sage being hanged. He showed no fear as he was hanged from an enormous tree along the Devil's Walk. As he dangled by his neck, but not yet dead, the crowd started to take grisly 'souvenirs' from the condemned man, cutting off his fingers, toes, his testicles, even his nose.

Once he had finally died his body was dismembered, being cut into four separate pieces, and was buried at a crossroads, so that he wouldn't be able to find his way to heaven and would have to take the road to hell.

John Sage is the most famous ghost at Chillingham Castle. Visitors have claimed to see him along the Devil's Walk, or in the King Edward Room. Others have heard footsteps followed by the sound of someone dragging something behind them, the ghost of John Sage dragging his leg behind.

The ghosts of Chillingham Castle are worthy of a book in itself, as there is not a room in this imposing fortress that isn't believed to be haunted.

The King Edward Room, in the most ancient tower of the castle, is said to be the most active. The room is haunted by many spirits including the malevolent spirit of John Sage. It is common for the heavy chandelier to swing from the ceiling on its own. The room has a high balcony running all the way around it and dark shadows are often seen moving swiftly around the balcony.

I have visited the castle on many occasions, and on one visit in 2015 a member of staff, who helps with the ghost hunts that take place at Chillingham Castle, told me of some of the occurrences they had witnessed themselves in that very room, after dark. One that really sticks in my mind to this day involved an investigation, where the lights were off, and all of a sudden there was a scream, and a young man ran from the room, desperate to get out of there. When he regained his composure, he explained he'd been sat on a stool and someone, or something, had grabbed his leg, trying to pull him off the stool. A sceptic asked if he could go and sit on the stool and see if anything would happen to him. The investigation continued and almost immediately the sceptic was screaming for help. He explained that something had grabbed him from behind and was trying to drag him off his seat, almost pulling his coat off. When he removed his coat, his back was covered in scratches that looked like claw marks.

There is a small dungeon called the oubliette, which translates to 'to forget' in French. This is where prisoners who held no information, so weren't of benefit to

The King Edward Room.

torture, would be held. Most often this would be children. There are marks on the wall where those chained up in here would have counted how many days they'd been held here. No one would be released; instead their arms and legs would be broken, and they'd be thrown 20 feet down a hole in the floor, covered with a heavy metal grate. This is where they would eventually die. Those lucky ones would die upon impact from the fall, but others would die slowly, either from starvation, or from infection from their injuries. Often they would land on the bodies of those who'd die before, and a survival instinct would kick in, leading them to eat the flesh from the bodies of the dead. A member of staff at the castle told me that John Sage had a dog, and he would feed his dog with the meat of those killed in the oubliette, although that's not something I've seen or heard anywhere else

Today, if you look down through the grate covering the oubliette below, you'll see the broken, skeletal remains of the last person to have been killed here, a twelve-year-old girl, staring back up at you with her hollow eyes.

Perhaps unsurprisingly, it's not uncommon for people to pick up on emotions of despair and sadness in this room. There have also been wails and groans heard coming up from the empty pit below where so many people lost their lives.

The Great Hall stands between two towers and was added in Tudor times. It is laid out like a medieval banquet hall with a large table in the centre of the room. At

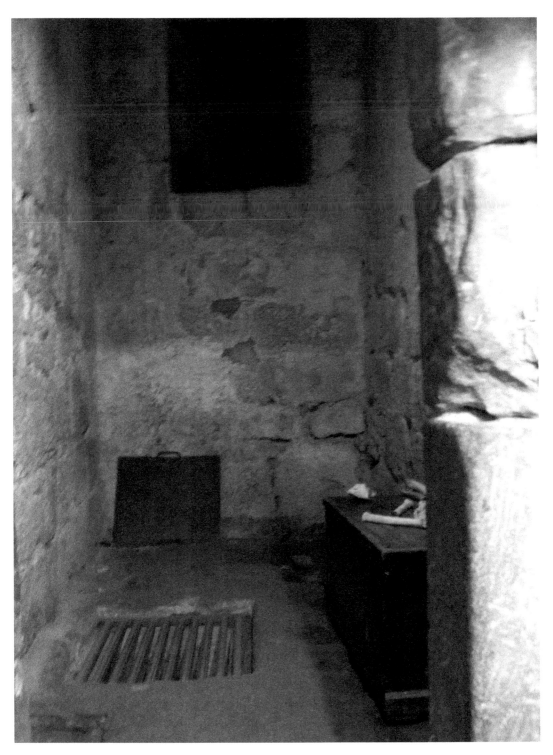

The oubliette.

The oubliette when viewed through the door at the front of the castle, through which the bodies would be removed.

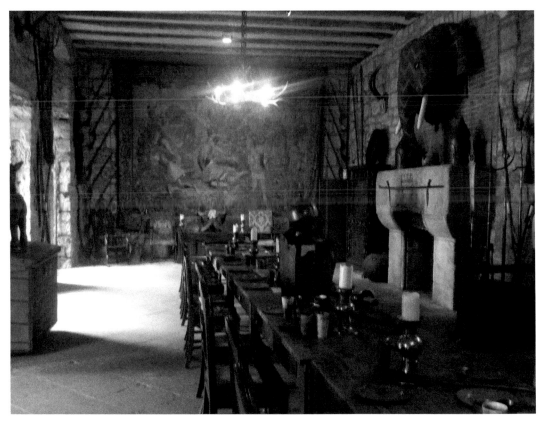

The Great Hall.

one end of the room hangs an enormous tapestry, and it is at this end of the room where most of the unusual happenings have occurred. Cold spots, with temperatures dropping in a matter of seconds, is commonplace, and whispered voices are heard right in visitors' ears, so close they can feel, and smell, the breath on their face. People stood in the courtyard have often seen figures passing by the windows within the Great Hall, when the room has been empty.

On the balcony known as the Minstrel's Gallery, people have been walking down the narrow staircase and felt hands in their back, trying to push them down the stone staircase. While on this balcony, people regularly suffer from terrible headaches and/ or an awful feeling of nausea, then they are overcome by an overwhelming feeling of wanting to throw themselves over the balcony onto the stone floor below.

Another well-documented spirit at Chillingham Castle is that of the Blue Boy, also known as the Radiant Boy, who haunts the Pink Room. For centuries, his wails and cries were heard each night around midnight, sometimes accompanied by the spectral form of a young boy bathed in blue light. His identity was never known, but this mystery appeared to be solved in the 1920s when during renovations the body of a young boy was found walled up along with some blue cloth left from his clothing. He'd been walled up alive, and the bones of his fingers were worn away from where he had been trying desperately to claw his way out. He was given a burial in

consecrated ground and his spirit found peace at last. The moans and sightings ceased, and he was never seen again. Or was he? Those staying in the Pink Room in recent years have reported seeing a sudden blue flash in the wall, almost like an electrical fault. However, a thorough investigation has proven that there's no electric wiring running through that particular wall.

Three human skeletons were found in the chapel. Two adults were found beneath the floor near the stained glass window, and the other, that of a little girl, was found beneath the floorboards in the rear corner of the room. No one knows who they are, or when, or why they were buried here. The spirit of the little girl appears to be drawn to female visitors to the castle, and the most common reporting is the feeling of a small child appearing to try and hold their hand. When they turn to see who's there, the sensation stops. People have stood in the spot in which her remains were found and been overcome with grief. Some have even wept uncontrollably.

Lady Mary Berkely is another famous ghost of the castle. She lived here in the seventeenth century, when her husband, Ford Grey, was lord of the castle, following his father's death in 1675. She loved him dearly, and they had a daughter, also called Mary. Lady Mary's heart was broken when her husband committed the ultimate betrayal and seduced her sister, Lady Henrietta. The following year the pair fled to France, and Lady Mary and her young daughter were left all alone.

The chapel.

To this day the rustle of her dress is heard, and a chill is felt, as she walks the corridors and the stairs searching for her estranged husband. In the 1920s a portrait of Lady Mary Berkely hung in the nursery. The family at the castle, and their staff, were only too aware of the lady stepping out of the painting and walking the castle after dark. The painting was sold prior to the castle being abandoned in 1933, but her tragic spirit remains.

The ghosts of Chillingham Castle aren't confined to the castle, as the grounds of the castle are certainly no safer for any unsuspecting visitor. A phantom funeral procession has been seen on several occasions in the garden area. A headless man is seen slowly walking the gardens, usually in daylight hours. The beautiful lake may look peaceful and tranquil; however, there are untold horrors lurking just beneath the surface, for the lake was used as a dumping ground for the dead Scottish prisoners from the castle. They'd been brought from the castle by the wagonful and dumped into the water. Legend has it that the lake is cursed; if you put your hand into the water the souls of the dead will pull you under and you will never surface again. Screams, moans, and sobbing are heard here late at night and at least one apparition has been seen walking from the lake.

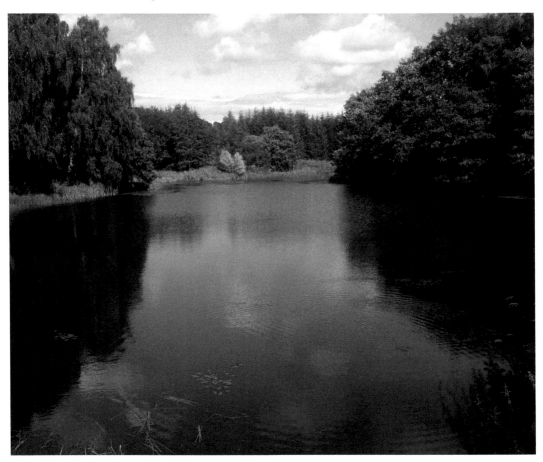

The lake.

Open Spaces

The beautiful county of Northumberland has vast miles of forests and fields. It is wild and remote. It is actually the least populated county in England, with only sixty-two people per square kilometre. Considering this, it's unsurprising that some of these open spaces are believed to be home to far more than woodland creatures, bats and birds.

Bolam Lake Country Park

The delightful Bolam Lake Country Park is right in the heart of the Northumberland countryside. It is a 25-acre lake surrounded by woodland, historic landscapes, and incredible views. It's a popular spot, especially in the warmer months, with visitors enjoying the lakeside walk, having picnics in the sunshine, and fishing for the big pike. It is well known for its wildlife, with red squirrels, roe deer, and woodpeckers all being seen here.

It was a completely different animal, however, that saw the country park thrust into the headlines in early 2002. Twilight had set in, and a party of fishermen were sitting quietly on the lakeside, sipping at hot drinks to ward off the chill, while intently watching their floats hoping for a bite. However, they soon realised that someone, or something, was watching them just as intently. They saw the eyes first. 'Glowing red eyes' they later described them as, then the 'thing' stood forward into a clearing, no more than 10 feet away from them. They described it as being 8 feet tall, covered from head to toe in thick dark hair, and had huge fang-like teeth. They ran for their lives, but the creature didn't give chase, or at least they don't think it did – they were too terrified to dare to look back.

This encounter reached the local media and featured in the local newspapers and on local radio as a light-hearted story with the monster given the nickname of the 'Geordie Yeti'. What they hadn't expected though would be that these reports would come thick and fast in the days, weeks, and months to follow. The creature was being seen on a regular basis, even during the day, and each eyewitness described seeing the same thing. One even claimed that they heard it before they saw it, as when it walked the ground shook.

'The Beast of Bolam Lake', as it was now known, quickly caught the attention of the national press, and people were daring to ask the question; could this thing actually be real? Was it possible that some kind of bigfoot-type creature was living in a country park in Northumberland? The notion had captured the imagination of the British public.

Bolam Lake at dusk.

One of the locations where 'the beast' was witnessed.

Someone who had been following the story closely was Jonathan Downes. Downes, a professional 'Monster Hunter' and Director of the Exeter based Centre for Fortean Zoology, found the story so compelling that in January 2003 he, and his team, headed north to Bolam Lake Country Park and spent five days and nights in the woodland in the hope of seeing the beast for themselves.

It wouldn't take five days.

At dusk on the second day, five of the eight-man team saw the Beast of Bolam Lake. As the final drops of daylight ebbed away, and gave way to darkness, nesting rooks who had been singing loudly in the trees suddenly fell silent. At the very same moment there was a huge disturbance in the woodland across the other side of the lake from where they were positioned. They turned on car headlights and the cause of the disturbance was illuminated, a very tall man-shaped creature who ran at an incredible speed to their left, before vanishing out of view, and then turning around and running to their right before they lost sight of it entirely.

At the conclusion of the five-day investigation, Downes told the media:

The expedition was a success beyond our wildest dreams. The most exciting thing was that five people I interviewed had seen the beast at the same time – I was one of those people.

Bolam Lake frozen over during winter.

What I saw was a dark, man-shaped object approximately seven-and-a-half feet tall.

It had a barrel chest and thick muscular arms and legs. I had a very clear sighting but I saw no glowing eyes and wasn't able to tell whether or not it was covered in hair.

Interestingly, Northumberland is believed to be home to another bigfoot-like monster, as a legend connected to Rothbury is that of the Deugar, who is said to stalk walkers and campers, capture them, then roast them alive over an open fire in his cave on the Simonside Hills, before feasting on their flesh.

The Bonny Lass of Belsay is believed to be the restless spirit of the daughter of a rich Newcastle merchant called Caroline, who lived in the area in the eighteenth century. She was riding her horse near Bolam Lake, when it was spooked, and reared up, throwing her off and striking her head against a rock, cracking her skull, with a fragment of it piercing her brain, killing her.

The 'Bonny Lass' has been seen throughout the area of Belsay, as well as within the country park at Bolam Lake. She is described as a spectral temptress with long golden hair, and a beautiful rustling dress. Any man unfortunate to cross the Bonny Lass will

Could a bigfoot-type creature really call this country park home?

become transfixed by her and follow her wherever she may lead him. However, the moment he looks away, she is gone.

Winter's Gibbet

In a remote location high up in the Elsdon moors stands a monument to murder. Winter's Gibbet stands atop a hill overlooking Harwood Forest, surrounded by moorland as far as the eye can see. It was built to commemorate a cowardly attack that occurred in 1791, when a kind old lady was brutally attacked and killed by William Winter and sisters Jane and Eleanor Clark.

Margaret Crozier lived at Raw Pele Tower, 2 miles north of Elsdon, and she sold cloth from her home to make a living. She was known and liked in the area, to the point where locals would come and buy from her, even if they didn't need the items they bought, as they just wanted to help her out. Jane and Eleanor happened upon Margaret's home one day, and spoke to the old lady about what she had for sale. Margaret invited them inside, and as Margaret talked through her wares, the sisters had noticed just how many items of value were lying around Margaret's home.

The sisters had become friendly with a man by the name of William Winter, who had recently arrived in Elsdon having just been released from a spell in prison. Winter had been a criminal all his life, and it ran in the family as his father and brother had been hanged in 1788 for theft. Jane and Eleanor told him of the frail old lady, living in a remote location, with a home full of items that could be easily sold for a tidy sum. Winter took no convincing, and the three of them hatched a plan.

Winter's Gibbet.

The 29 August 1791 was a particularly stormy night. The perfect night to rob an unsuspecting old lady with no chance of anyone else being in the area in such foul weather. Jane and Eleanor hid just out of sight as Winter knocked on the door. The old lady answered, surprised to have a visitor at this late hour in such bad weather. The soaked stranger shivered as he explained that he was not from the area and had lost his way in the storm trying to find his lodgings. The ever-trusting Margaret didn't hesitate to invite the stranger out of the rain and into the warmth of her home. No sooner had he crossed her threshold, Winter launched an attack on Margaret, hitting her so hard that he fractured her skull, killing her in an instant. The sisters dashed inside, and the three of them gathered up everything of value that they could before making their escape.

Because of the isolated location of Margaret's home, the three criminals thought they'd be safe to stay in Elsdon another day or two before moving on. However, this

Winter's Gibbet in 2007, complete with head which is no longer present.

proved to be a fatal mistake. The storm had passed and the trio were sat on a hillside when an eleven-year-old shepherd called Robert Hindmarsh happened upon them. They exchanged pleasantries, but Robert had noticed that Winter had been eating an apple with a very distinctive knife. A knife that he knew belonged to Margaret Crozier. He told the police of this, and the body of Margaret was discovered. Winter and the Clark sisters were arrested.

The three were executed at the Westgate in Newcastle on 10 August 1792. The corpses of the sisters were given to a local surgeon to be dissected in the name of medical studies. Regarding Winter's remains, it was decided that due to the outrage of the people of Elsdon over the death of the much-loved Margaret Crozier, an example should be made. His body was returned to Elsdon in a cart where it was hung in a gibbet cage at Whiskershields Common, 3 miles to the south of the village. His corpse was left there for all to see, for the animals and insects to feast upon, until all that was left was his skeleton. At this point his bones were scattered within 100 metres of the gibbet, and his skull was sent to a Mr Darnell in Newcastle. Who Mr Darnell was, and what happened to William Winter's skull, is lost to time.

The site of Winter's Gibbet today is not the original site. This replica was erected in 1867 at the request of Sir Walter Trevelyan of Wallington Hall. It originally was complete with a wooden version of William Winter, but this was removed when it was getting used for target practise. This left just his head dangling from the macabre

Winter's ghost has been seen near this cattle grid.

monument, and this would regularly be stolen, being replaced time and time again, until eventually it wasn't, and now nothing hangs from Winter's Gibbet.

The ghost of William Winter is seen late at night at the site of the replica gibbet. This is peculiar as he didn't die here, nor was the original gibbet at this spot. Even more unusually is that the most common location of sightings of the William Winter's restless spirit is at a cattle grid, near Harwood Forest, roughly 100 metres from where the replica gibbet now stands. Those who claim to have encountered the terrifying ghost of William Winter have described a skeletal phantom with putrid green flesh and hollow eye sockets, covered in rusty chains.

Perhaps some of his bones ended up in Harwood Forest as many late-night visitors to the forest have encountered a groaning sound followed by a distinctive shuffling of feet and the rattle of chains.

The ghost of Margaret Crozier is altogether more benign. It has been claimed that she still haunts Raw Pele Tower, which is now part of Raw Pele Farm. Her spirit is said to be often seen walking between the farm buildings after dark. She is also to blame for doors and windows suddenly swinging open.

Towers

Between the twelfth and sixteenth centuries pele towers, sometimes spelt peel, were constructed along the English and Scottish borders. Free-standing tower structures, they were built to be defensively sound and to act as watch towers to warn of approaching invaders.

Due to Northumberland's strategic position, seventy-eight pele towers were constructed throughout England's most northern county. Sadly, only a small proportion of these are still standing today. Here we will look at those that some believe to be the haunt of ghosts, ghouls, and even a snarling black beast.

Cresswell Tower

Dating back to the thirteenth century, Cresswell Tower is located in the beautiful village of the same name. It is only a short distance from Druridge Bay, a 7-mile-long stretch of beach and dunes that runs north to Amble. The tower was the seat of the Cresswell family, one of the oldest families in Northumberland. A mansion house was built adjoining the tower in the eighteenth century, but less than a hundred years later it was destroyed. The only evidence that it ever existed was the roof groove you can see on the north wall of the tower. A grand hall, named Cresswell Hall, was built to the west of the tower in 1821, but lasted a little over a century, before being demolished in 1937. The tower now stands alone in woodland next to a caravan park named for the historic building. For many decades the tower wasn't structurally sound and had to be locked to visitors. The structure has undergone a programme of excavations and an extensive renovation in the last decade, and in the summer of 2021 opened for the first time for visitors to enter, and enjoy the historic tower, on selected days.

A sad tale that has become synonymous with Cresswell Tower is the story of a beautiful daughter of the Cresswell family, who fell in love with a young Danish prince. The brutal Viking raids on England had ended much earlier, and a lot of the Danes had settled across England. The beautiful girl was besotted with her prince, and he occupied her every waking thought. When he asked her to marry him, she thought she'd died and gone to heaven. She immediately said yes, and the couple could not have been happier or more excited about their future together. However, the girl's family was far from overjoyed at this prospect. Despite this prince being far too young to have ever been a Viking, their hatred of the Danes remained, and despite not saying anything to their daughter, they would not stand for this union.

The wedding was planned and the happy couple had arranged to be betrothed at Cresswell Tower. The locals had really taken to the charming prince, and a huge crowd of well-wishers gathered to see the couple wed.

Above and below: Cresswell Tower.

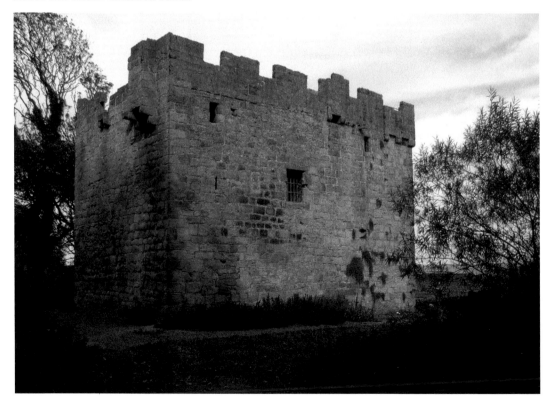

The bride-to-be was the happiest woman alive, as she stood atop of Cresswell Tower, looking out towards the coast for her beloved. Off in the distance she saw a horse galloping along Druridge Bay. It was her prince. She was overflowing with excitement. However, in an instant, her joy turned to horror. She saw three men emerge from the sand dunes and attack him, one of them stabbing him with a spear, pushing the tip upwards, piercing his heart. She recognised the attackers. They were her brothers.

The prince slumped forward in his saddle as the horse galloped towards the tower. He slipped from the saddle and fell from the horse, his ankle getting tangled in a rope, dragging him behind. The crowd saw the horse approaching and let out a huge cheer, but as it got ever closer they could see there was no one riding the horse, and when it got closer still, they could see someone being dragged behind. It wasn't long before they recognised the prince, and they managed to calm the horse and untie his foot. But he was dead.

The girl was watching this unfold below her, and she was beside herself with grief. Whether she fainted or decided she couldn't face life without the man she loved we will never know, but she fell from the top of the tower to her death. It is said that to this very day her ghostly form can occasionally still be seen gazing out to sea from the tower roof. The spirit of the Danish prince is not seen, but he is often heard, a single, bloodcurdling scream of agony coming from the dunes at Druridge Bay, followed by the pounding of horse's hooves.

A ghostly sword fight is heard in this area of the woodland that surrounds the tower.

Another unidentified pair of ghosts have been heard duelling, their swords clashing outside the building, while others say the invisible wheels of a horse-drawn carriage crunch on the driveway.

Otterburn Tower

Otterburn Tower stands today as the magnificent Otterburn Castle Country House Hotel. The hotel is set in 32 acres of land, with beautifully manicured terraced lawns to the front and woodland walks to the back. There's even an exclusive 3-mile stretch of the River Rede teeming with salmon and trout. The hotel's master suite, complete with four poster bed, was once the tower's library.

The original pele tower at Otterburn was built sometime between 1245 and 1308. In 1388 the tower was subject to the most brutal attack in the building's history. On 18 August a Scottish army arrived in Otterburn and attempted to capture the tower by force. They had, however, underestimated the defence of the tower, and despite attacking long and hard, they ultimately were left with no choice but to retreat. Most of the Scottish lords wanted to return north, across the border, and retreat back to Scotland, but they were under the rule of the Earl of Douglas, and he refused to accept defeat in his want to take Otterburn Tower. Fortunately for those stationed at Otterburn, reinforcements arrived the next day, led by Harry Hotspur and his Percy

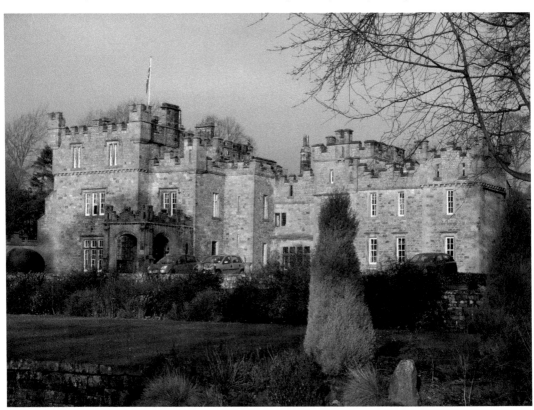

Otterburn Castle Country House Hotel.

army. The focus on capturing Otterburn Tower was quickly forgotten as a bloody battle commenced. During the Battle of Otterburn the Earl of Douglas was killed, and the English troops suffered heavy losses and were ultimately defeated.

The tower suffered many attacks as the border wars raged on, and off, for the next three centuries. By 1540, the exact date is lost to time, the Hall family, a powerful Northumbrian clan, had acquired the tower. The most famous of the Halls was 'Mad Jack Hall', a well-known Jacobite sympathiser who was hung at Tyburn, a manor in Middlesex, in 1716.

By the eighteenth century there was no longer the threat of attack, and the tower's primary purpose ceased to be defence. Reginald Hall rebuilt Otterburn Tower as a country house, adding 'a square building of the Scots farmhouse style'. Further additions were made throughout the nineteenth century by Thomas James, before being sold in 1900 to Howard Pease. It changed hands again in the 1930s, and in 1947 the tower was converted into a hotel.

Otterburn Tower has a long history of ghostly occurrences. The sound of marching footsteps have been heard inside the tower, commonly in areas that have been known to be unoccupied, as well as throughout the tower's ground. A phantom woman, known as the Grey Lady, has been seen wandering the corridors but little is known of who she is, or why she remains at the hotel to this day.

Strange, inexplicable sounds, ranging from whispering to screaming and clawing noises, have also been heard late at night by visitors staying at the hotel. Guests have also reported all manner of foul stenches, complaining to hotel staff of sulpher-like smells, but they disappear as quickly as they appear.

Preston Tower

Preston Tower was built in 1392 by Sir Robert Harbottle. The tower originally stood as a long building with turrets at the four corners. Due to war with Scotland, and the constant threat of Border Reivers, it was essential to have a fortified house. The fortress is first mentioned in the List of Fortalices in 1415.

Sir Robert Harbottle was twenty-six years old when he built the tower and in the same year he committed a murder, although he was later pardoned. Fourteen years earlier in 1378 he will have been with his father, Sir Rafe Harbottle, at the Siege of Berwick alongside the Earl of Northumberland's son, Sir Henry Percy. Percy, aged only fourteen at the time, fought with such bravery that he earned himself the nickname 'Hotspur' and went on to become a Northumbrian hero, fighting in many battles that would shape Great Britain.

Sir Robert was made Sheriff in 1408, and then Constable of Dunstanburgh in 1409. He died on 6 May 1419 and his son, also called Sir Robert Harbottle, succeeded him and became sheriff in 1439, until his death four years later.

Two generations later, Sir Guiscard Harbottle of Preston lost his life in hand-to-hand combat with King James IV of Scotland at the Battle of Flodden in 1513. Sir Guiscard's daughter, Eleanor, took over Preston Tower and married Sir Thomas Percy. Sir Thomas was executed on 22 August 1572 for his part in 'The Rising of the North', a plot to re-establish the religion of their ancestors, remove councillors, and free Mary Stuart, Queen of Scots, from imprisonment. The tower was confiscated by the crown and

Above and left:
Preston Tower.

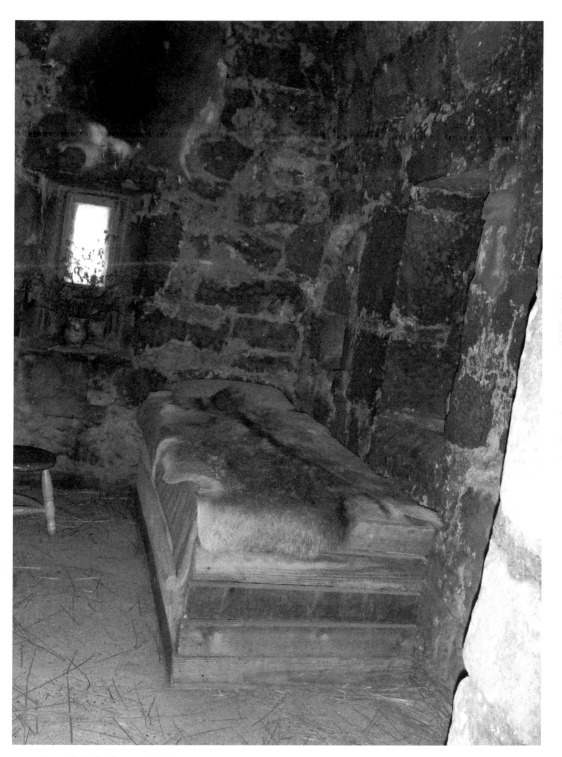

One of the bedrooms in the tower.

The dungeon in the tower.

leased back to members of the Harbottle family until it was sold to William Armourer in 1663, although the tower now stood with only two turrets and one joining wall, as in 1603 two of the turrets had been pulled down and a farm steading was built around the tower and the stone was used for cottages. Preston Tower changed hands in 1719 and then 1805, before it was finally sold to A. J. Baker Cresswell in 1861.

In 1864 Henry Baker Cresswell carried out the restoration on the tower. The adjoining cottages were removed, although even today traces of this can still be seen in the stonework. A bell was also installed, which was cast in Newcastle and weighs 500 kg.

Today, the tower is set out as it would have been in the early fifteenth century and has informative displays throughout. Anyone choosing to visit, however, should hope that they don't encounter the Preston Hound.

The Preston Hound was a creature as tall as a horse and as heavy set as a lion, with a thick black coat and red, hate-filled eyes. Legend has it that this beast was once employed to deter undesirable visitors to the tower. However, he became uncontrollable and his keepers feared for their own lives, so they fed the creature a hunk of meat soaked in poison. As the poison ravaged his body and began to sap his life, the beast broke free from his chains and attacked those that had poisoned him. He tore them to shreds, ripping arms, legs and heads off in a frenzied attack. As the Preston Hound lay dying, all that remained of his killers was a mutilated pile of limbs,

The views across the Northumberland countryside from the top of Preston Tower are stunning.

blood, and raw flesh. However, in death the creature remained loyal to his masters, and it is said that he will appear if Preston Tower is ever threatened.

It may be a legend, but people have actually claimed to see a large black dog-like creature at the side of the tower in the area where the cottages were removed during the restoration. Loud, deep growling noises have also been heard coming from the woodland nearby after dark.

Voices and footsteps coming from the upper levels of the tower are often reported by visitors, who then discover that there is no one else there and they are in fact alone.

More Castles

Let's take a look at more of the many castles in Northumberland, which have a dark, violent past, which has left its mark today in the form of the ghosts and ghouls that are rumoured to haunt these ancient, ruined fortresses.

Warkworth Castle

The first recorded mention of the village of Warkworth was in AD 737 when the church and village were given to the abbot and monks of Lindisfarne at the order of Ceowulf, the King of Northumbria. The first castle at Warkworth, a motte-and-bailey

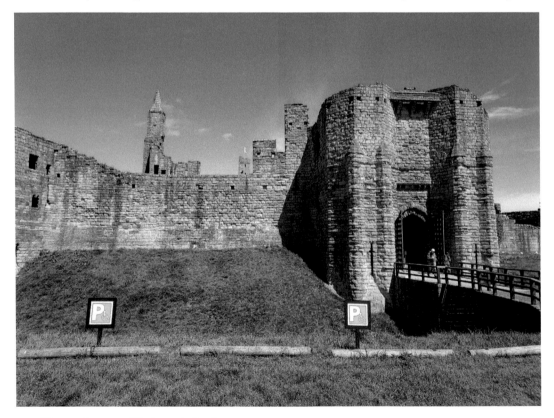

The gatehouse to Warkworth Castle.

structure in wood, was constructed around 1140 by Prince Henry of Scotland, son of King David I of Scotland. It was built on a high, defensive mount at one side of the peninsula of land formed by the curving River Coquet, with the village and river crossing protected by the castle. The Scots invaded Warkworth in 1173, and again in 1174 and the weakly constructed castle was all but destroyed.

That second invasion occurred on Saturday 13 July 1174, which proved to be the darkest day in the history of the village of Warkworth. The villagers rushed to St Lawrence's Church, as it was made of stone and offered more protection than the wooden castle. However, it would ultimately do them little good, as the Scots, under Duncan, Earl of Fife, massacred the vast majority of the village. When the Scots left Warkworth, 300 of the men, women and children of Warkworth lay dead.

Warkworth Castle remained in ruin until 1199 when it was rebuilt and expanded, and in the early thirteenth century was rebuilt in stone.

In 1332 it was passed on to Henry de Percy, Lord of Alnwick, and it is with the Percy family that Warkworth Castle is primarily associated and in particular the dashing Northumbrian hero Harry Hotspur, who was knighted at the age of twelve and then fought in the siege of Berwick aged only fourteen. The castle remained with, and was constantly improved by, the Percy family until 1569 when they sided against Elizabeth I in the Rising of the North.

Their estates were seized and Warkworth Castle was left empty. It started to crumble and decay. This was helped further during the seventeenth century when stone from the castle was reclaimed to be used in the building of local homes.

Restoration began in the mid-nineteenth century, and in 1922 the castle was handed over to the Office of Works to continue this restoration work, who would become English Heritage. They still manage Warkworth Castle to this day.

The impressive ruin of Warkworth Castle, today, dominates the skyline for miles around, and its cross-shaped keep is incredibly atmospheric. Unsurprisingly, it is believed to be home to a number of restless spirits.

A grey lady is said to haunt the keep. She is seen as a full spectral apparition, accompanied by the swish of her long dress. It's unclear who she is, but it's been written that she may be the ghost of Lady Eleanor Neville, wife of the 2nd Earl of Northumberland.

A young man wearing chain mail has been reported to be seen walking the ruined castle walls and standing guard at the gate tower. He appears so real, so solid, that visitors who have caught sight of him have commented to staff how great it is to have staff dressed up, as if in the period of the castle. To which staff respond that none of the staff are dressed up, and it's probable they've seen the ghost. Some believe this to be the spirit of Harry Hotspur; it's a romantic notion, but the truth is that his identity will forever remain unknown.

On 28 April 1489 there was outrage at the high taxes enforced by Henry Percy, 4th Earl of Northumberland. Riot broke out and Henry Percy was killed, with a Yorkshire man named Tom Sherratt landing the killing blow.

He was arrested and taken to Warkworth Castle, where he was held until the murdered earl's successor would decide his punishment. He was placed in the oubliette, a small dungeon, literally translated from the French for 'to forget', and that's exactly what happened to Sherratt, for the 5th Earl lived in the south, and didn't come to Warkworth for two whole years, by which point Sherratt had not been

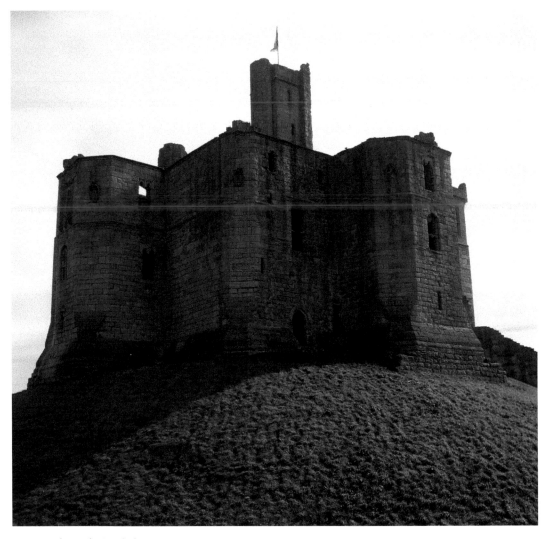

Warkworth Castle keep.

outside that windowless room, had not spoken a word, and didn't even know his own name, or why he was there.

The earl, taking pity on the prisoner, rather than sentencing him to death, he allowed him to live at Warkworth Castle providing he earned his keep. He was put in the charge of the man who tended the castle's dogs.

Tom's sanity deteriorated further and he thought he was one of the pack, living on all fours, eating and sleeping with the dogs.

Visitors to Warkworth Castle have often said they've heard a howling while in the keep, said to sound 'like a dog, but almost human'.

Warkworth's most famous spectre isn't to be found in the castle, but is instead located at short way upstream at Warkworth Hermitage, where the tragic ghost of the Hermit of Warkworth resides.

A large amount of the castle remains today, including the curtain walls, as can be seen here.

Sir Bertram of Bothal, a small village between Ashington and Morpeth, was at a banquette at Alnwick Castle, as he was one of Earl Percy's most trusted knights. He was in love with Isobel, the daughter of the Lord of Widdrington, and at the grand feast he promised her that he would prove his love by carrying out a feat of great courage and win her hand in marriage. Isobel loved him equally and agreed.

A battle began shortly afterwards, and Sir Bertram went into the conflict determined to prove his love. He fought fearlessly, killing a number of Scots, before a Scottish sword struck him across the head from behind. His helmet took the brunt of the blow, and he was injured, but not fatally so.

He was taken to Warkworth Castle, where he was treated and would recover. A message was sent to Isobel to let her know of what had happened to her beloved, and as soon as word reached her, she set out for Warkworth. However, she would never reach the castle, as she was captured by Scottish soldiers and imprisoned at a Scottish stronghold.

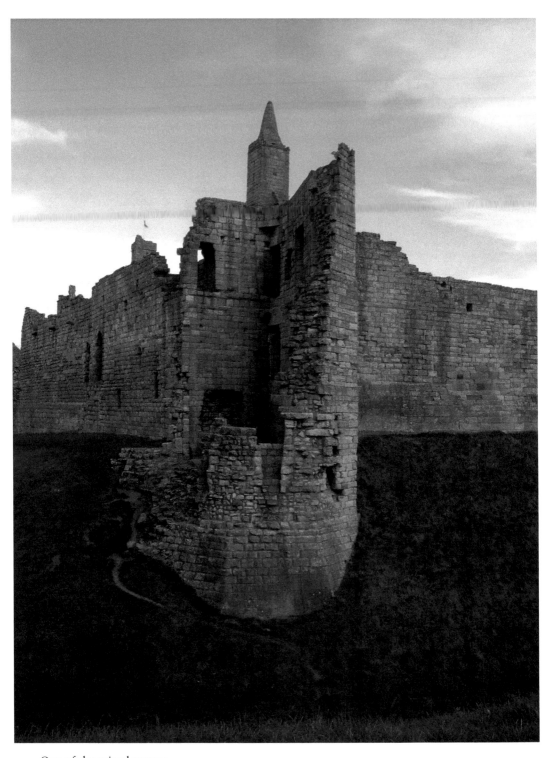

One of the ruined towers.

When Sir Bertram had recovered he set out to see Isobel, accompanied by his brother, but upon arriving at her home was horrified to hear that she'd set out weeks earlier to see him.

He immediately knew the Scots must have captured her and swore not to rest until she was safe in his arms. His brother offered to help, and the two of them split up, setting off in different directions looking for leads on where she was being held.

Days turned into weeks, and weeks to months with no news, and Sir Bertram now feared the worse, but a chance meeting with a monk gave him hope, as he was told that the lord of a nearby Scottish castle was holding a pretty young girl captive.

Sir Bertram raced to the castle and positioned himself in a cave with a view of the castle entrance, to wait, and watch, for any sign that his Isobel was indeed being held there, before making his rescue attempt.

Three days and nights came and went, but then on the fourth night, his patience was rewarded. He saw a Scottish clansman arrive at the castle on horseback, enter the castle, then leave shortly afterwards with a beautiful young woman. It was Isobel.

As the Scot was helping Isobel onto the back of his horse Sir Bertram made his attack, approaching the Scot unseen and taking his head clean off his one swing of his sword. Isobel screamed out, causing the horse to rear up, throwing Isobel to the ground, where her head struck a rock, killing her in an instant.

Sir Bertram was a broken man. He held the woman he loved in his arms, and it was only then that he saw the dismembered head of the man. It was his brother, who had been in the process of saving Isobel.

Sir Bertram lay on the ground, as if dead himself.

Eventually he made his way home, where he gave away everything he owned. He sought permission from the Earl Percy to use a small plot of land where he could build a small home for himself, away from the world, to see out his days in solitude.

A short way upstream of the castle on the banks of the River Coquet, hidden by trees, he built a hermitage with his own hands. Carving the unusual building from the limestone rock, he built it to contain a chapel and a dormitory. The tiny chapel contains an effigy of a beautiful young woman, her hands raised in prayer. At her feet kneels a hermit, his hand pressed to his heart. This is Lady Isobel and the hermit that Sir Bertram had become.

He lived out his days alone, never uttering a single word to anyone. A servant from Warkworth Castle brought food each day, which he did for twenty years, until one winter's morning he found the now old and weak Sir Bertram sitting at a fire that had almost gone out. The boy offered to go for firewood, but Sir Bertram grabbed his arm, pulled him close, and tried to speak, eventually saying, in almost a whisper, 'Isobel' with his last breath.

The inscription Sir Bertram carved above the hermitage door is a lasting reminder of the torment and guilt he felt. Translated it reads 'My tears have been my meat night and day'.

Sir Bertram's tragic ghost has been seen at the hermitage knelt in prayer. He has also been seen wandering the bank of the river close by, head bowed as if deep in thought. People have almost felt sadness and even started weeping without knowing why.

The Hermitage at Warkworth.

Edlingham Castle

Edlingham means 'homestead of the sons of Eadwulf', and the village of Edlingham's recorded history dates as far back as AD 737 when 'King Coelwulf gave Edlingham to Cuthbert'. There's some confusion over who this Cuthbert may have been, as some, mistakenly, claim this was Saint Cuthbert of Lindisfarne, but he had died fifty years earlier in AD 687.

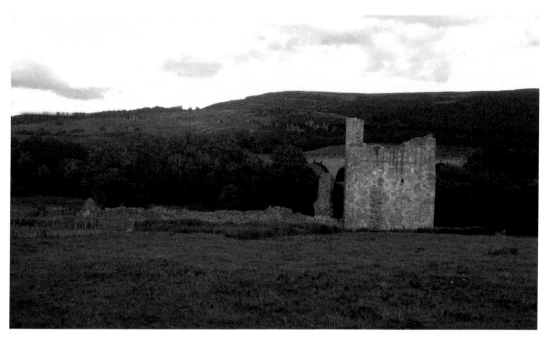

Above and below: Edlingham Castle.

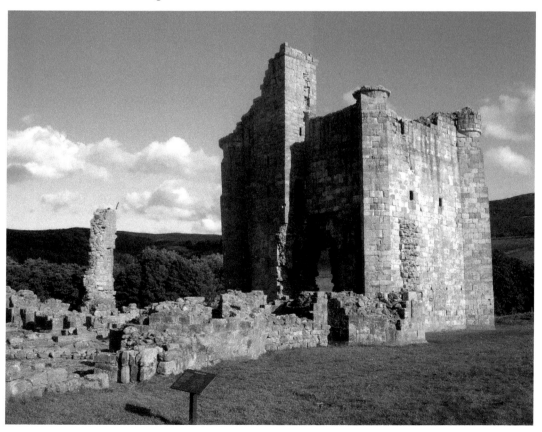

The remote village of under 200 residents lies in the valley of Edlingham Burn, surrounded by a landscape of scarps, fields and vales. Corby's Crags, a high moorland, overlooks the small settlement of nineteenth-century cottages that make up the village.

In the twelfth century John de Edlingham built a two-storey house near the burn containing a hall, parlour, chambers, bakehouse, brewhouse and a kitchen surrounded by a moat.

The constant threat of raids from north of the border led to the house being fortified in 1296 by Sir William de Felton. He added a strong palisade inside the moat with a gatehouse on the north side. The building was improved and expanded frequently, and by the end of the fourteenth century the house was referred to as a castle.

As the centuries passed, as well as the threat of the castle coming under attack, the purpose of Edlingham Castle changed, and eventually the building and land were used for farming.

In 1650 the castle was abandoned, and was never inhabited again. In the over 350 years since, the building rotted, decayed, and stone from the building was taken to be used in the construction of other buildings and walls in the village. Eventually the ruined castle was buried completely under 6 feet of soil. In 1978 English Heritage dug the castle remains out and made them safe for visitors.

In the seventeenth century a lady called Margaret Stothard lived in Edlingham. She was popular, for a time, with the locals, and earned a reputation as a 'charmer' with an ability to help the sick. However, her willingness to help soon backfired, as someone suggested she must be a witch, and in seventeenth-century England the merest suggestion of such things would see the woman brought to trial for witchcraft. Despite helping the sick of Edlingham, everyone turned on her and demanded that as a witch, she must be killed.

The Margaret Stothard witch trial took place in 1682. Local lady, Jane Carr explained, at the trial, that in 1671 she thought that her daughter was behaving very strangely, as if not in control of her own thoughts so turned to Margaret for help. Kindly Margaret was more than willing to see what she could do, and upon visiting the Carr home, she whispered something into the child's ear, then, in Jane's own words, 'put her mouth to the child's mouth and made such a chirping and sucking that I thought she had sucked the heart out of it'. Jane's daughter was immediately cured of whatever had ailed her and returned to her normal self. However, Margaret was seen outside, acting as if possessed herself, ranting and seemingly going mad. Margaret approached a goat and whispered something to the beast. The next day the goat had gone crazy and had to be killed. The Carr family testified that they believed Margaret somehow removed a demonic spirit from their daughter and then passed it into the poor animal.

Isabel Maine told that she was a milk maid, and on an occasion in 1678 she was unable to get the milk to curdle into cheese, as hard as she tried. She asked Margaret if she was able to help, and Margaret told her that the cause was most likely a witch looking at her cows with 'ill wishes'. She suggested that Isabel rub salt mixed with water on the cows back to protect them. This worked and she was able to produce cheese once again, and bring more money in. Despite helping Isabel, she still testified against her, and said that she clearly has knowledge of witchcraft.

Some were convinced that Margaret was equally capable of using her powers to do the Devil's work. John Mills, agent of the Swinburnes of Edlingham Castle, said that

Above and below: Dark shadowy figures move swiftly among the ruined areas of the castles.

one Sunday night, in 1683, he was lying in bed in the castle, unable to sleep, when he heard a mighty gust of wind, then 'Something fell with a great weight upon his heart and gave a cry like a cat'. Then there was a light at the end of his bed, and in the centre of it was the vision of Margaret Stothard looking directly at him. It terrified him so much that 'the very hairs of his head would stand upward'. He cried out 'the witch, the witch' and then he suffered a fit so bad that it awoke his family who had to hold him down until it passed.

Jacob Mills, John's brother, who also gave his address as Edlingham Castle, also gave evidence against Margaret. He said that Margaret had approached him and his family, asking for donations for the poor, but they turned her away. When she was turned away Margaret waved a 'white thing' at them three times. The next morning, their daughter was very ill and cried out that 'the woman was pressing her like to break her back and press out her heart'. She died and Margaret, the witch, was blamed.

When judgement was passed on Margaret the trial, led by magistrate Henry Ogle, ended without a verdict, despite the evidence given against her. What happened to Margaret after the trial is unknown; she may have lived a long life, or the fearful locals may have taken matters into their own hands. We may never know.

Edlingham Castle is a real hidden gem among the wealth of supposedly haunted castles in Northumberland. The ruin is accessible any time of day and night, and visitors after dark have seen dark shadowy figures moving swiftly around the barely standing stonework. Strange glowing lights, appearing to move purposely, are also seen. Footsteps are heard walking on floorboards above visitor's heads, even though there are no longer any floorboards there.

Some have claimed to have felt invisible hands tugging at their clothes, and a medium who visited the ruin, unaware of these reports, claimed that a young girl remains here, trying to get people's attention by pulling on their clothes and even trying to hold their hand.

Places of Worship

Northumberland became a deeply religious Christian kingdom in AD 634, when King Oswald sought out Christian teachers from Iona, Scotland, in a bid to convert his people to the religion and relinquish their pagan customs. The first missionaries failed, but were replaced by Aidan and a small group of Irish monks. They settled at the island of Lindisfarne, as it reminded them of their island home, and it was close to the royal city of Bamburgh. Ever since the Holy Island of Lindisfarne has been known as the cradle of Christianity.

As the centuries have passed by since, there has been a huge number of churches, abbeys, and other religious structures built across the county. And of course, they too have their fair share of ghost stories.

The Holy Island of Lindisfarne

Holy Island, also known as Lindisfarne, is one of the most important centres of early English Christianity. It is famous worldwide for its enormous religious heritage, and this is one of the reasons why the small tidal island, with a population of just 147, receives around 650,000 visitors each year. It is separated from the mainland by a 3-mile-long causeway that floods twice a day.

In the seventh century Aidan was the first of sixteen bishops at Lindisfarne, and he founded a monastery on the island. The most famous of the Lindisfarne bishops was Cuthbert. Within two years of his appointment as bishop in AD 685, he predicted his own death and retreated to his humble cabin on Inner Farne, one of the Farne Islands. His prediction proved correct, as he died on 20 March 687, and in AD 698 he was declared a saint.

The Vikings raided Lindisfarne on 8 June 793, the first major Viking raid on Britain and an event that started what is now known as the Viking Age in Europe. In a violent attack, monks were put to the sword. Gold, silver and precious religious artefacts were stolen, and the church's shrine of St Cuthbert was destroyed.

Almost a century later, the threat of Viking raids was still a constant fear, so in AD 875 the monks on Lindisfarne decided to abandon the island. They took with them precious religious artefacts including St Cuthbert's coffin, St Aidan's bones, and the Lindisfarne Gospels. They travelled for eight years and then settled in Chester-le-Street, but they moved again, ending up at Durham in AD 995. This is where St Cuthbert was finally laid to rest, being buried at Durham Cathedral in a grave marked with the name Cuthbertus. The remains of his wooden coffin and the relics are now displayed in the Cathedral Treasury.

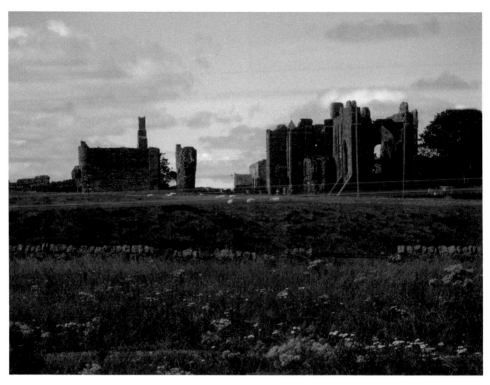

Above and below: Lindisfarne Priory.

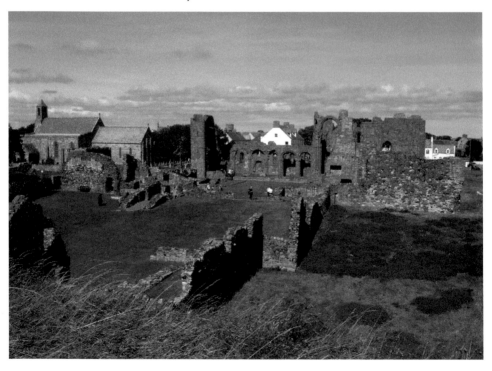

For almost 200 years Lindisfarne was completely unoccupied, and the buildings on the island, including the church and monastery, rotted and decayed. The process accelerated due to the close proximity to the North Sea. In 1082 monks from Durham came to Lindisfarne, and Lindisfarne Priory was constructed on the site of the former monastery. With the threat of the Vikings no longer an issue, life was simple and happy for the monks. This continued until 1537, when Henry VIII's Dissolution of the Monasteries left the priory empty and unused.

In 1550, with turbulent times between the English and the Scottish to the north, Lindisfarne Castle was built on the highest point of Lindisfarne, on a stone hill called Beblowe. Much of the stone used in the construction of the castle came from the disused priory.

Lindisfarne's most reported ghost is that of the island's most famous former resident. A phantom, believed to be that of St Cuthbert, is seen across the island, most

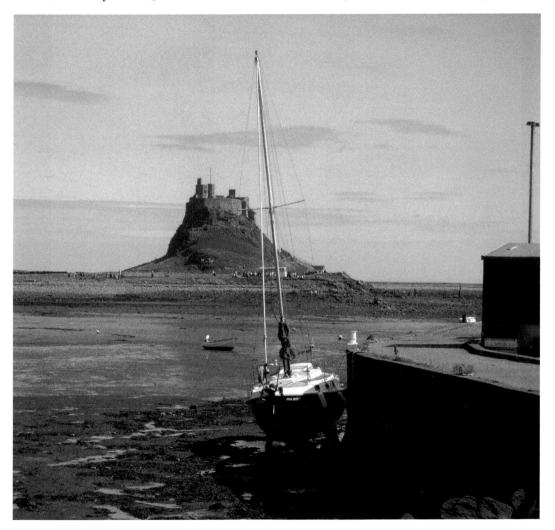

Lindisfarne Castle.

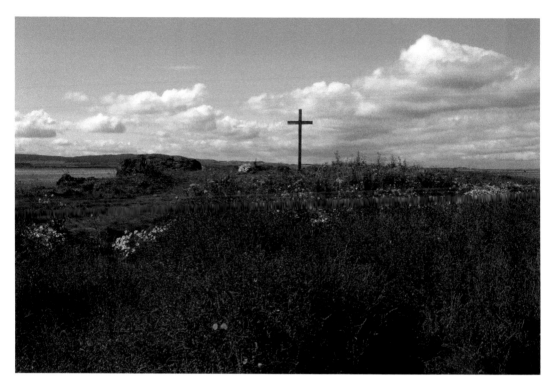

St Cuthbert's Island.

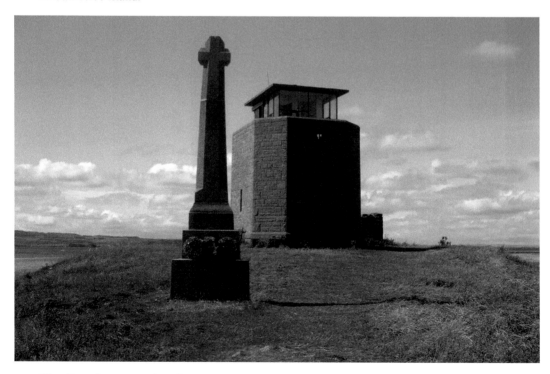

The disused coastguard station.

usually in the priory and on the island named for him. Easily identifiable by the large wooden cross in the centre, St Cuthbert's Island is accessible at low tide, but at high tide it is separated from Holy Island by the sea. This is when Saint Cuthbert has been seen peacefully sitting on the rocks of the tiny island.

The priory is home to another ghostly monk, who rather unusually appears dressed in white, as opposed to the typical black habit. He has never been witnessed by the naked eye, but has appeared in visitor's photographs. His identity is unknown.

In the 1930s two fishermen reported seeing twelve ghostly monks crossing the island at high tide, walking above the water. They were not sighted crossing on the causeway that modern cars would use to get to the island, but instead were following the 'Pilgrim's Way', a series of stepping stones used by monks in the eleventh century to cross to the island. This route is marked today by a series of stakes close to the motorist's causeway.

A phantom is seen looking out of the windows of the disused coastguard station. It is described as appearing with a skeletal face, partially covered in shrivelled leathery green skin, and hollow eye sockets.

Lindisfarne Castle is the haunt of a large white dog, called a shuck, which is said to jump out on anyone wandering near the castle late at night. It then slinks back into the shadows from whence it came.

The Church of St Mary the Virgin

Dating back over 1,200 years, the Church of St Mary the Virgin in Woodhorn, Ashington, is the oldest church in Northumberland. The architecture of the church today includes Norman, Saxon and Gothic, but is mostly nineteenth-century construction.

The earliest legible grave dates from 1717, and among the other 400 headstones are the graves of miners killed in mining accidents and brave soldiers who lost their lives at war.

Tom Chalkley died in the First World War and has been blamed for haunting the graveyard ever since. George Charlton was the Assistance Sexton at the church during the war. Tom was well known and well liked in the village of Woodhorn, and George was surprised to see him walking through the churchyard, apparently deep in thought, as he thought Tom was in the trenches fighting for his country. At the same time Tom also appeared to his parents, showing his fatal wounds. The official telegram of his death would arrive weeks later, and he died at the exact time he had been seen in both of these locations at the same time. The ghost of Tom Chalkley is said to haunt Woodhorn's graveyard to this very day.

The lane that runs outside the church is haunted by a fearsome, phantom cyclist known as the Paddler. Only ever seen at dusk, he rides a distinctive rusty, black bicycle with a white stripe on the rear mudguard. No one knows who he is, or why he cycles the same route time and time again, but he wears filthy pitman's clothes with heavy, muddy boots and a dirty cap. His skeletal face has empty eye sockets, and a gaping lower jaw puncturing his grey, dried-up skin. His rotten, black teeth rattle inside the skull as he pedals past the church.

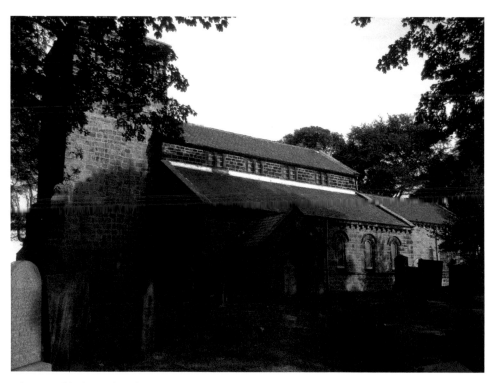

Above and below: The Church of St Mary the Virgin.

The haunt of the Paddler.

Blanchland Abbey

Dating from 1165 and constructed by Walter de Bolebec II, the abbey at Blanchland started as a priory for the Premonstratensians, an order that had only been founded forty-five years earlier in Laon, France.

In the late thirteenth century it became an abbey, and despite Blanchland coming under Scottish attack during the Anglo-Scots wars, the abbey was, rather miraculously, ignored completely.

Following the Dissolution of the Monasteries, the abbey was dissolved in 1539 and passed into private hands. In 1612, what had formerly been the abbot's house was converted into a manor house. The estate of Blanchland was bought by Lord Crew in 1704, and upon his death in 1721, he left it to the Lord Crew's Charity, to be used for charitable causes.

Later in the 1720s, the manor house became an inn, and remains today as the Lord Crewe Arms, itself a well-known haunted location, featuring in its own right in the next chapter of this book.

Nestled in a beautiful remote valley in the northern Pennines, the abbey gatehouse survives, as does the early thirteenth-century north transept and the chancel, but the remainder of Blanchland Abbey, as it stands today, was constructed during the eighteenth century, making it a unique, yet beautiful, place of worship.

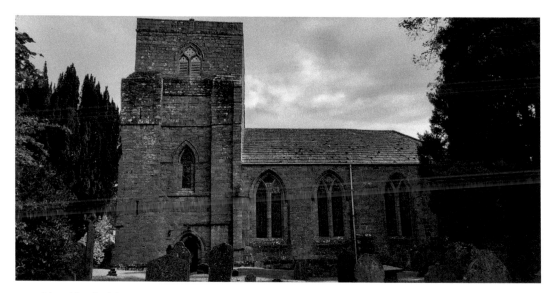

Blanchland Abbey.

The churchyard at Blanchland Abbey.

The abbey has a legend that dates back to those times when the threat of attack from the Scots, especially being so close to the border, was a constant fear. It has been written that the monks of Blanchland Abbey prayed to God to spare the abbey. Their prayers were answered as a thick fog fell across Blanchland, completely shielding the village and the abbey from view. The Scottish raiders rode straight past, and Blanchland was spared that day. Or so it seemed.

However, one foolish monk was so keen to let everyone know that it was safe that he rang the abbey bells before the Scottish invaders were out of range, and they turned

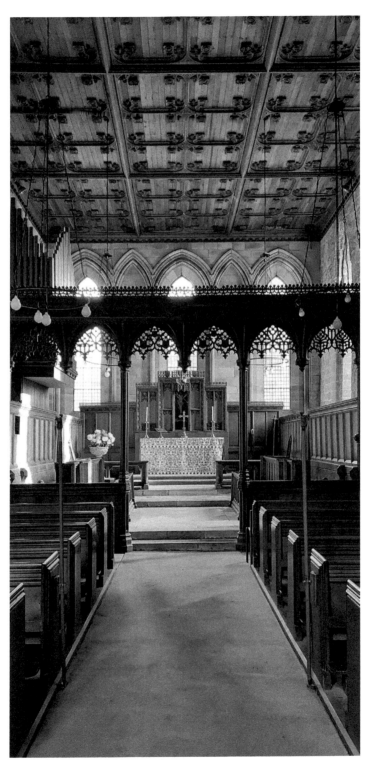

The haunted abbey.

Blanchland is in a valley surrounded by the beautiful countryside of the northern Pennines.

their horses around and ransacked the village, slaying the men, women and children of Blanchland by the dozen. The monks wouldn't escape their grisly fate, and they too were put to the sword. It was a massacre.

The abbey is believed to be haunted by the monks who lost their lives that very day, seen weightlessly floating through the churchyard. Those who have witnessed them appear to tap into the emotions of that day, being overcome with grief and sadness.

There have been numerous reports of those exploring the tranquil churchyard feeling that they're being watched by unseen eyes.

Hotels, Halls, Inns, and a Caravan Park

Northumberland has a wonderful array of pubs and hotels, where you can grab a drink, or get a good night's sleep. We also have some magnificent old halls, where you can while away an afternoon, marvelling at how the richer families of a bygone age must have lived in luxury.

And they are perfect places to look for ghosts. The myriad of phantoms that stalk the rooms and corridors of these beautiful old buildings, for eternity.

Let's look at some of the scarier examples to be found in Northumberland.

Schooner Hotel

The Schooner Hotel, in Alnmouth, a small village at the mouth of the River Aln, claims to be one of the most haunted hotels in Britain, with over sixty individual ghosts. The seventeenth-century inn undoubtedly has a rich and troubled history. Famous figures such as Charles Dickens and King George III are said to have visited the Schooner.

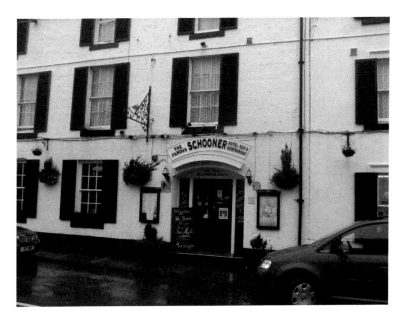

The Schooner Hotel.

The Schooner Hotel was constructed at a time when Alnmouth was a popular port for goods coming in and out of the country. Soon, the Schooner would become the drinking establishment of choice for these smugglers, so much so that a secret tunnel was created in the cellar leading down to the nearby beach. This would allow the smugglers to come and go from the beach unseen.

The most famous of the Schooner Hotel's resident spirits didn't actually lose his life in the 400-year-old building. By the mid-eighteenth century the Schooner was brewing its own ale, and in 1742 a cask was sent to the village's parson, a man by the name of Parson Smyth. He was moved by such a thoughtful gift, and one evening he decided to give it a try. He was connecting the tap to the cask when it shot off and struck him in the head, killing him.

The tap was returned to the inn, and the superstitious locals believed that if anyone else was to use the tap, the same fate would surely befall them. Other versions of the tale, say that they believed the Parson's blood would flow from the tap. Parson Smyth is said to walk the ground floor of the Schooner Hotel to this day.

On Christmas Eve 1806 there was a fierce storm, and a woman waited by the fireside inside the inn, awaiting the safe return of her husband, who was a fisherman. Given the late hour, their six-year-old daughter was asleep on her lap.

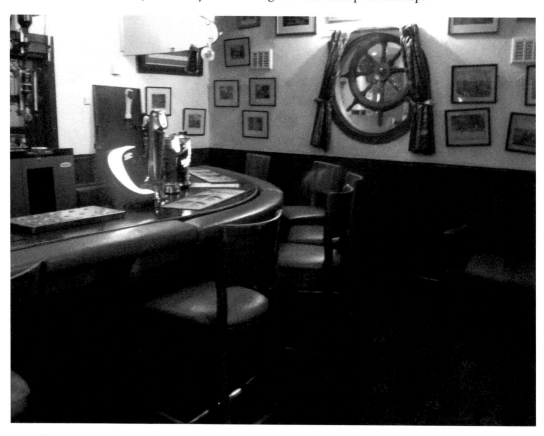

The Chase Bar.

Suddenly the door burst open, the wind and rain poured in, and it was followed by a man. He had raced to the Schooner as quickly as he could and was out of breath. He gave the news that the woman was dreading: the storm had capsized a boat and a man had drowned. It was her husband.

She fainted at the tragic news and struck her head on the fireplace as she fell. Her sleeping daughter fell from her lap and landed in the roaring, open fire. She awoke immediately and began screaming, as the flames began to consume her. Men drinking in the bar, thinking nothing of their own welfare, reached into the fire and pulled her burning body out. She was awake, but very badly burnt; her face had all but melted away from the intense heat. She died within minutes.

When her mother came too, and saw her burnt, dead daughter, she was inconsolable. In a matter of minutes, she'd lost her husband and her child. She ran off into the stormy night in hysterics and was never seen again.

The spirit of the young girl, who is affectionately nicknamed Lizzie, haunts the Chase Bar. She is a friendly spirit and is said to run around the tables before heading towards the fireplace, where she vanishes.

Room 28 is said to have been the scene of a massacre. A married couple and their children, called the De Vere family, came to England from France and spent a night in the inn. They were shown to their room, which is the current room 28. As they opened the door, a gypsy snuck up behind them and struck all four hard across the head with a heavy object. The four unconscious bodies were then taken into the room, where they had their throats slit. The gypsy took anything of value from their bodies and their luggage, and then all four bodies and their bags were taken down to the beach, via the secret tunnel, where under the cover of darkness they were loaded up into a boat and dumped at sea.

The most haunted spot within the hotel is the area in which this cold-blooded murder took place. In room 28 dark shadows are seen moving swiftly around the room, often out of the corner of guest's eyes, but when they turn to look, they see nothing. Guests have also reported feeling sick and/or dizzy, but the moment they leave the room they feel fine. The spirit of a young boy and a girl have also been seen, and heard, playing in room 28 late at night, most often by staff passing, when they know there is no guest booked into that room on that particular night.

The flooring in this particular area of the hotel is the original timber floor from when the hotel was built, and this has led to people hearing the floor creak as invisible feet walk along it. This has terrified some guests when they are stood in the corridor alone and hear footsteps walk towards them, through them, and on down the corridor.

Another room that is said to have been the scene of a murder is room 4. The details vary in each telling of the story, but a man is said to have been asleep when an intruder broken in and strangled him to death. This has led to some guests claiming to have heard the sound of someone gasping for air, whereas others have felt icy hands around their throat.

The corridor that runs past rooms 15 to 19 is said to be the haunt of a male toddler. His identity, and reason for remaining at the Schooner, is unknown, but he is said to cycle his little tricycle up and down the corridor, and scuffs and scratches found on doors and skirting board have been blamed on him and his little trike.

Room 30 is a room that has frightened many guests, some to the point of fleeing the hotel in the middle of the night. A sudden, inexplicable drop in temperature is felt.

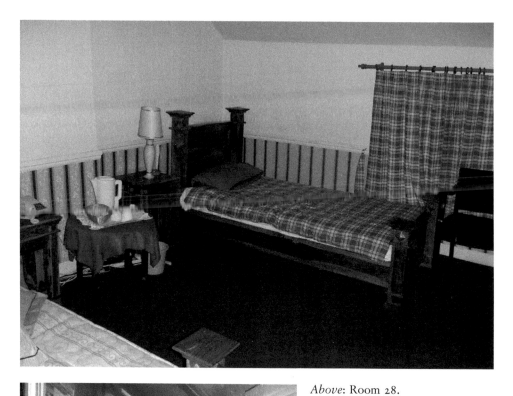

Above: Room 28.

Left: The corridor outside rooms 28, 29 and 30.

Then the room is found to be locked, and it appears impossible to unlock. They are trapped inside. Then they see him, the tall, dark shadow of a man-shaped figure, right there in the room with them.

In a hotel boasting over sixty individual ghosts, it will come as no surprise that there are a number of spooks and spectres that don't appear to be tied to any one area of the hotel. A man dressed in a military uniform has been seen in numerous rooms, with people most commonly claiming to wake up and see them stood at the foot of their bed looking directly at them. A ghostly chamber maid has also been seen throughout the hotel.

The Dirty Bottles

There is an inn on Narrowgate called the Dirty Bottles. Over 200 years ago the innkeeper died while placing bottles in the window. His widow claimed soon after that whoever attempted to move the bottles would be cursed with bad luck and would die. They've never been touched since, being sealed between two panes of glass. The old bottles are thick with dust and cobwebs.

The Dirty Bottles.

The Lord Crewe Arms

The history of the Lord Crewe Arms is very much intertwined with the history of Blanchland Abbey. The building was built in 1165 as an inn and guest house for the newly constructed abbey, or priory as it was at the time. After almost 400 years, the Dissolution of the Monasteries in 1539 saw Blanchland Abbey cease its use, as it did the guest house.

After almost two centuries of changing hands, the estate of Blanchland was bought by Lord Nathanial Crew, the then Bishop of Durham. The old guest house was given to his wife, Lady Dorothy Crew.

Upon his death in 1721, the estate, including the old inn, became the responsibility of the Lord Crew's Charity Shortly afterwards the Lord Crewe Arms was opened for the people of the village, and 300 years later that's what it remains as to this day.

The ghost story of the Lord Crewe Arms dates back to the time between the estate of Blanchland being bought by Lord Crew and his passing, and the creation of the Lord Crewe Arms. The famous ghost who has stalked these ancient walls ever since is Dorothy Forster.

In 1715 her brother Tom was taken prisoner in Newgate, London, due to his part in the Jacobite rising. Dorothy courageously hatched a plan to save him from certain execution.

She rode from Adderstone, near Bamburgh, to London, and three days before his trial sprung him free with the help of a blacksmith friend. In order to outwit the authorities looking for the escaped rebel she filled a coffin with sawdust and placed it inside the family vault at Bamburgh, claiming that he had headed overseas, where he had died.

However, he was taken to Blanchland, where he hid in a priest's hole in the building that would later become the Lord Crewe Arms, as Lady Dorothy Crew was their auntie and only too happy to help to keep her nephew's head from the chopping block.

Tom hid for a short while until attention on his escape had died down, and then he successfully fled to France.

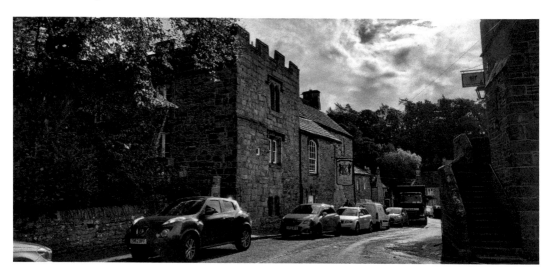

Above and opposite: The Lord Crewe Arms.

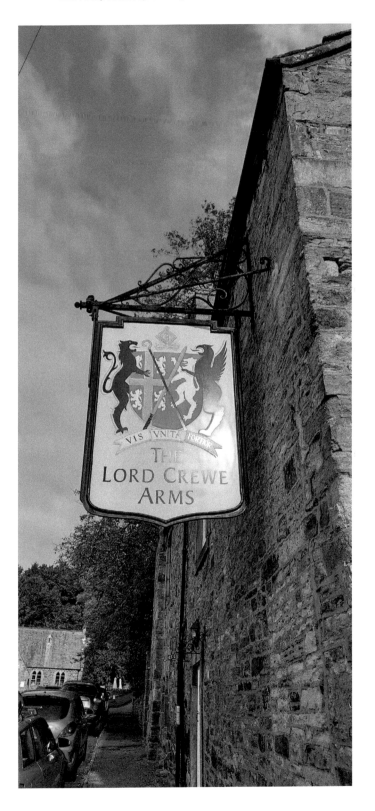

The ghost of Dorothy Forster has been reported ever since at the Lord Crew Arms, most commonly in a room that was, for many years, called the Bamburgh Room. The rooms were all renamed by the current owners, who are keen to distance themselves from their inn's haunted heritage.

She is said to appear to the guest staying in the room, begging them to take a message to her brother in France on her behalf. The message is that he can now return home safe. She then vanishes before anyone can question her further.

In the 1990s, an American guest staying in the room that was called the Radcliffe Room at the time claimed to wake up to see a ghostly monk sat at the foot of her bed. She wasn't scared and reached out to touch the figure. At the moment her hand met the spectre, he faded away.

Seaton Delaval Hall

The de la Vals were loyal supporters of William the Conqueror, and Sir Hendrick de la Val married Dioysia, William's niece. As a result, following the Battle of Hastings and the Norman Conquest, they were granted land in Northumberland in the 1080s.

The came over to England from Maine, France, and settled in the area, and by 1270 their estate was called Seton de la Val, seton meaning 'sea town', due to their close proximity to the North Sea. They lived a modest life until 1311 when they started generating huge sums of money by allowing coal mining on their estate. A castle and family home had been built upon the estate by the beginning of the fifteenth century.

At some point during this period de la Val became Delaval, and Seton de la Val became Seaton Delaval.

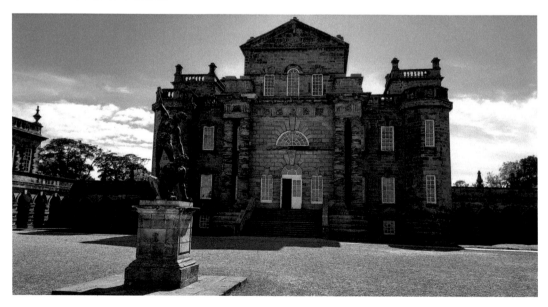

Seaton Delaval Hall.

Work began on the present hall, for Admiral George Delaval, in 1718, who had bought the estate from his cousin the previous year. Seaton Delaval Hall was designed by Sir John Vanbrugh and cost £10,000 to build. It was completed eight years later, by which time both Admiral Delaval and Sir John Vanburgh had both died. The hall and the estate were inherited by Captain Francis Blake Delaval, Admiral George's nephew.

On 3 January 1822 a fire gutted the hall, destroying the main building, leaving nothing but the stone shelf of the structure.

After thirty-eight years without a roof, famed Newcastle architect John Dobson came to the hall in 1860 in order to carry out restoration on the hall, but the cost was too high and didn't happen.

Seaton Delaval Hall was uninhabited until the Second World War, when it was used to hold German prisoners of war.

Restoration work was carried out on the hall during the 1950s and 1960s, but it would be around 160 years before a Delaval would call the home again. Edward Delaval Henry Astley, 22nd Baron Hastings, moved there in the 1980s

He lived there until 2007, when he passed away. It was inherited by 23rd Baron Hastings, Delaval Astley. He didn't have any plans to live in the hall so asked the National Trust if they would have any interest in purchasing Seaton Delaval Hall, with its gardens and grounds, and maintain it to be enjoyed by people for decades, and centuries, to come.

The National Trust launched an appeal in September 2008 to raise the £6.3 million needed, and in December 2009 the hall was sold to the National Trust. Seaton Delaval Hall is currently undergoing a £7.5 million of repairs and renovations.

A hall as magnificent and historic as this has, of course, its own resident ghost. There is a window on the first floor of the east wing, where the White Lady stands, staring out, waiting for her true love. She was in love with a Delaval heir, and died of a broken heart, because they were forbidden from being together.

Legend states that she will haunt the ancient hall until a male Delaval is born inside the walls of the hall.

Haggerston Castle Holiday Park

The date most commonly attributed to the origin of Haggerston Castle is 'some time before 1311', as history records that King Edward II visited the castle in that year. However, what we do know is that the castle was in the ownership of John de Hagardeston prior to his death, and he died in around 1210, a whole century before the visit of Edward II.

The main reason for the lack of knowledge around the early history of Haggerston Castle is that much of the documentation held at the castle has been destroyed in a number of fires.

Haggerston Castle was in the de Hagardeston family, which would become Haggerston with Thomas Haggerston in c. 1458, until 1839 when gambling debts saw it taken over by the Naylor family.

In 1891 it was inherited by Christopher John Naylor, who changed his name to C. J. Leyland. He made Haggerston Castle his family home and set about a

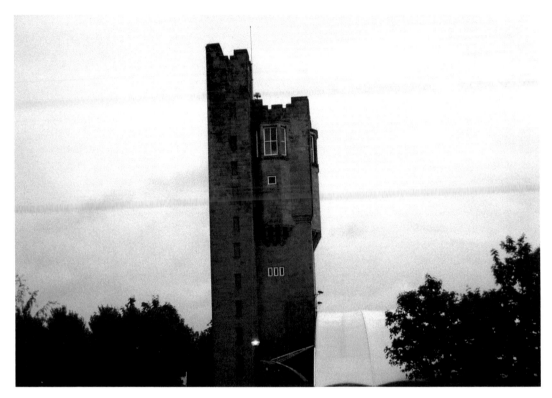

The tower at Haggerston Castle.

huge series of improvements to the 23,000-acre estate, including rebuilding and remodelling the main house and an enormous programme of landscaping including adding an Italian garden.

Disaster struck in 1911 when fire destroyed the house and damaged everything beyond repair, with the exception of the tower and the rotunda.

This fire was blamed on a curse, said to have been cast on Haggerston Castle by a witch in the sixteenth century. She said that three major fires would ravage the castle. This curse has proven true on two occasions, so far, as prior to the 1911 fire, there was an equally destructive fire in 1618.

C. J. Leyland died in 1933, and with his passing the hugely damaged estate of Haggerston was auctioned off in 2,000 separate lots, including the ruined house.

Little remains of Haggerston Castle today – just the tower, rotunda, and stable block. These are all Grade II listed buildings, and are incorporated into Haggerston Castle Holiday Park, a caravan park owned by Haven Holidays on 256 acres of land, which was once part of the Haggerston estate.

The tower is used as a storeroom and the rotunda is the Activities and Leisure Fun-zone. The cellars were converted into a bar and storerooms, but are now closed to the public.

So, a haunted caravan park? You better believe it. I conducted a paranormal investigation at Haggerston Castle in 2014, and it was fascinating to speak to staff about some of the things they have experienced themselves. Terrifying, in stark contrast to the harmless family fun going on all around the park.

I was told that the rotunda, which was used as a lounge for owners of holiday homes on the park at the time, is very active, with staff having seen the ghost of a young girl in Victorian clothes. Two weeks prior to my visit, a member of staff called Rae had been working at his desk in the rotunda when he had a frightening experience.

He told me 'It was about 6.15 p.m. and I was the only one there. I suddenly felt the temperature drop and it got quite chilly. Then the radio came on, all on its own. We normally have it tuned to BBC Radio Newcastle but this was just a buzz. I know there have been sightings of a little girl so I said "So you want to play then." There was no reply or anything else otherwise I would have been out of there like a shot!'

I was also told that above the rotunda is a room where computers connected to the internet and pool tables are accessible. In one particular spot in that room, next to a stone pillar, is what has been described as a vortex. If someone stands still in it, people have claimed they can feel themselves swaying, to the point where they feel they are going to fall over, but they never do, as if an invisible force is preventing you from doing so.

Strange noises are heard coming from the cellar when it is known to be empty.

The stable block is part of the original estate, and we've had people run out of there in terror. On one occasion someone was touched when they were in one of the stable cubicles.

The stable block.

A small child has been seen throughout the amusement arcade area.

The Walled Garden Summer House.

The amusement arcade area has had a small child seen throughout, and the summer house in the garden is also said to be haunted by a small child. Whether these are the same child is unknown.

The boating lake is another area popular with holidaymakers, but what they won't know is that some believe that the body of a woman and her young daughter are at the bottom of the murky depths. Families have fun floating around on swan-shaped boats, oblivious to what lies only a short distance beneath them. A psychic who visited the holiday park is attributed with this claim, as she said she could see a vision of the mother and daughter stood on a pier before jumping, or perhaps being pushed, into the water, never to resurface. It was later confirmed that there was once a pier at the lake.

The main ballroom has security cameras, and these have picked up on orbs seeming to move with purpose around the room. Shadowy figures have also been seen. At least one member of the night security staff has left his job because of 'creepy goings-on'.

A few years prior to my visit a piano was pushed off the stage by unseen hands. It landed on a small child injuring them. Staff have said that this room in particular has a horrible feeling, and electrical equipment such as cameras and mobile phones are drain of power for no apparent reason. Mobile phones also turn themselves off and on, far more often than for it to just be a coincidence.

The Italian garden.

The castle's tower dominates the park and can be seen for miles around. In 2011 a paranormal investigation focussed on the tower, and I was told that 'the ghost hunters heard metal being dragged across the floor and footsteps running around above them. The team also spent some time in the cellar but one member refused to go back in after feeling someone breathing down her neck'.

The Italian gardens, installed by C. J. Leyland, are home to a spectre, which some believe may be Leyland himself. I was told by staff that this spirit had been seen in recent months leading up to my investigation. A man was walking through the Italian garden, and he saw a figure, which walked towards him, then vanished as it got near to the man. The man fled immediately. When he told staff of what he'd seen he was white as a sheet and totally shaken up.

Even More Castles

There are even more castles within the county of Northumberland home to all manner of terrifying things that go bump in the night.

Kielder Castle

Kielder is a remote village in the far north of Northumberland, less than 3 miles from the Scottish border. It has a population of around 200, but visitors come to Kielder all year around.

Kielder is famed for its dark skies, as it is one of the darkest areas in all of Europe, and the fourth darkest in the world. This is due to the lack of light pollution, which has seen it awarded protected status by International Dark Skies Association, the leading international organisation working to combat light pollution worldwide. The dark sky zone over Kieder is almost 580 square miles, and is the second largest area of protected night sky in Europe.

With your naked eye you can see a truly 'dark sky' here, something that around 85 per cent of the UK population have never experienced. A sky filled with billions of stars, and you can even see the shadows of the Milky Way and Jupiter. The CPRE Countryside Charity has said that Kielder is the best place to stargaze in the UK. Kielder Observatory, high up on Black Fell overlooking Kielder Water, is understandably popular, and on those nights when the sky is awash with the Northern Lights, it's a spectacle that will stay with visitors for a lifetime.

Kielder also draws visitors from all over the world for its forest. Kielder Forest dates from the 1920 and 1930s and surrounds Kielder Water reservoir and the village of Kielder, and is the largest man-made woodland in England at 250 square miles. Three quarters of the woodland is comprised of forest, and due to its position away from human habitation, roads and railways, it offers a wonderful sanctuary for nature to thrive. There is a wide range of animals and birdlife, and 50 per cent of the red squirrels in England call Kielder Forest home.

Archaeological remains are regularly uncovered within the forest, often tied to the bloody battles during the Anglo-Scottish wars, which were fought upon the land that the forest now occupies.

Kielder Castle was built in 1775 upon a burial site dating back to c. 3000 BC. It was constructed for the Duke of Northumberland as a hunting lodge, and is today one of the forest's visitor centres.

Kielder Castle is yet another Northumbrian castle with a number of chilling tales associated with it. Visitors and staff have told of seeing objects move all on their own,

Kielder Forest.

Kielder Castle Visitor Centre.

and the sound of footsteps has been heard running up and down the main staircase, when no one has been there.

Unexplained voices and whispering have been heard, and apparitions have been seen. No one is sure who they are, but there is said to be a grey lady and a servant girl named Emma resident within the castle. Little is known of their history, or their ties to Kielder Castle.

In 2015 a psychic visited Kielder Castle and fled the castle in fear after less than an hour inside.

Hugh Percy, 1st Duke of Northumberland, who had the castle constructed in the eighteenth century, had a rule for his servants, and that was if any female members of staff should fall pregnant, they would be sacked and replaced.

One of the maid's, a young girl by the name of Marie, was in a secret relationship with a footman and fell pregnant. Terrified that she would lose her job, and her home, she confided in the duke's wife, Lady Charlotte. Charlotte was sympathetic to Marie's situation and promised to help her. They dressed Marie in loose-fitting clothes to hide the growing bump.

Marie gave birth to her child, a baby girl. However, tragically the baby was stillborn. Marie was devastated by this, and Charlotte said that she would ensure the tiny, lifeless baby was hidden, so that no one would ever know of the servant girl's secret. Charlotte asked Marie to build a fire in the fireplace before retreating to bed.

Charlotte placed the dead baby into the roaring fire and placed more logs into the fireplace until the fire had completely consumed the baby. Charlotte smashed the bones that remained until they were crushed and unrecognisable. When Marie swept out the fireplace the following day, she was unaware she was disposing of her own child's ashes.

The castle courtyard.

When I investigated the castle in 2016, this sight greeted me when I entered one of the rooms usually closed to the public during the day.

The spirit of that tiny baby remains at Kielder Castle today, and a ball of light is seen in the fireplace within the café, which is where the secretive disposal of her remains occurred.

The spirit of Lady Charlotte is another spectre believed to haunt the castle, and is a friendly phantom, felt touching visitors on the arm, or stroking their hair. She didn't die here; she passed away in London and was laid to rest at Westminster Abbey, but she clearly has returned to the building she knew so well in life.

Mitford Castle

Constructed in around 1170 by Richard Bertram, a Norman knight, Mitford Castle was built on the site of a previous Anglo-Saxon fort in a strategic position, high up, overlooking the River Wansbeck. The castle had a pentagonal keep, which made it the only five-sided castle keep in the entire country.

Over the course of less than 150 years, Mitford was seized, attacked, and besieged during a turbulent period of history. In 1318, a Scottish invasion of Northumberland, in which Mitford Castle itself was targeted, saw the castle all but completely destroyed. It was never rebuilt and remains today as a ruin of the twelfth-century shell keep and later curtain wall.

Mitford Castle.

One of the ruined wings of the castle.

It appears that because of these troubled times, a number of Mitford Castle's former residents remain among the ruins to this day.

In 1934 two young boys were playing in the castle remains at dusk when they heard a scream, which stopped them in their tracks. They looked around, wondering if it was someone trying to give them a fright; if so, it had worked. However, the reality was far more terrifying than they could have ever imagined. A spectral warrior leapt out from the shadows of the castle in front of the boys. The warrior wielded an enormous sword in one hand, and in the other hand he held a severed head. The warrior fixed them with a steely glaze, and the blood curdling scream came again, but it was not the warrior who screamed – it was the head. With this the boys ran in fear for their lives, not daring to turn to look back, and never returning to Mitford Castle again.

To this day is it said that screams can be heard coming from the ruined castle after dark.

After dark, being inside the ruin can be a frightening proposition.

Dunstanburgh Castle

The much-photographed Dunstanburgh Castle is a lonely ruin, isolated for miles around and strategically positioned on a cliff high above the unforgiving North Sea. Construction commenced on Dunstanburgh Castle in 1313 at the order of Thomas, 2nd Earl of Lancaster, and was completed in 1325. The resulting castle was the largest in Northumberland, at almost 11 acres in size.

Thomas was executed in 1322 for his opposition to the king, which saw him lead a small army of rebels at the Battle of Boroughbridge, so never got to see his castle completed. King Edward II took over the estate and the castle would change hands constantly until the mid-fifteenth century, only around 100 years after the castle had been built, when, damaged following the War of the Roses, it was left empty and decayed, and collapsed, as the centuries passed by. This was aided in 1524 when Thomas, Lord Dacre, took the lead from the castle roof to use at Wark Castle, which he owned at the time.

Today, Dunstanburgh Castle remains as a dramatic ruin in the care of English Heritage, and is popular with visitors in the warmer months.

Of course, a castle this atmospheric has its own ghost stories. If it wasn't for Thomas, Earl of Lancaster, there would be no Dunstanburgh Castle, so it seems only

Dunstanburgh Castle's gatehouse.

Above and below: The castle dominates the landscape for miles around.

fitting that his restless ghost walks the ruined corridors and staircases to this day. He died at Pontefract Castle, being beheaded by a replacement executioner, who was so inexperienced that he didn't know to sharpen his axe. As a result, it took eleven swings of his blunt axe to completely separate the earl's head from his body.

His ghost was drawn back to Chillingham, and his grisly spectre is a terrible sight. He is seen as a headless phantom, his shirt covered in blood, and his head tucked under his arm. His face bears a horrific grimace.

Margaret of Anjou, wife of Henry VI, haunts Lilburn Tower. She was at the Battle of Hexham in 1464, where her husband was one of the rebel leaders of the Lancastrian resistance against King Henry IV. Defeated, she fled to Dunstanburgh Castle, later making her way to safety sailing out of Dunstanburgh Port, which is now the small port at Craster.

Her spirit is seen at the parapet of the tower, and has been seen walking up the staircase, although the stairs no longer exist, so she appears to be walking through the air. She is heard to weep for those who lost their lives at the battle. Some tales speak of the name 'Henry' being called out from within the tower. This is attributed to Margaret, but it's unknown if the 'Henry' she so desperately calls for is her husband, who died at the Tower of London in 1471, or Henry Beaufort. He was Duke of Somerset and was not only a trusted friend of Margaret, but was also her lover. He was executed following the Battle of Hexham.

Dunstanburgh Castle's most famous ghost comes as a result of the legendary tale of the knight Sir Guy the Seeker.

First published in verse by Matthew Lewis as part of his *Romantic Tales*, in 1808, the tale of Sir Guy the Seeker tells of brave Sir Guy exploring Northumberland in search of quests befitting of a knight. One dark stormy, night, he came across the magnificent castle at Dunstanburgh, first seeing it when it was illuminated against the night's sky by a flash of lightening.

The entrance to the castle was locked, so he took shelter with his horse in an entranceway next to a single yew tree. The rain seemed to be never ending, and he patiently waited for first light, when he hoped he would be able to enter the castle. In the distance he heard the toll of a church bell, and on the final ring, which signalled midnight, a bolt of lightning struck the castle gates, bursting them wide open.

Sir Guy approached the entrance, when an elderly man walked out of the castle and approached him. He was enormous, with a long white beard. His bald head was covered in flames. He wore a long robe and had a fiery metal chain tied three times around his waist.

He told Sir Guy that he was a warlock, and within those castle walls was a princess, and unless the brave knight would come to her aid, she would surely die.

'Sir Knight, Sir Knight, if your heart be right, and your nerves be firm and true, Sir Knight, Sir Knight, a beauty bright in durance waits for you.'

Sir Guy didn't hesitate and raced inside, accompanied by the warlock. He was stopped by another gate, which was locked by a living snake as the bolt. Venom dripped from the snake's mouth and the ground sizzled where the acidic venom landed. The snake readied itself to strike, when the warlock struck it with his wand, and the snake was dead.

In the courtyard of Dunstanburgh Castle Sir Guy raced into an incredible, horrific scene. There was a crystal tomb, in which lay a princess, her eyes wide with fear.

Above and opposite: Lilburn Tower.

Guarding this tomb was over 100 skeletal horses and 100 armour-clad warriors, skeletal knights raised by an evil spell from all of the local graveyards to guard the princess. These warriors of the damned were all lying asleep on the ground. The two skeletons nearest the tomb were different from the rest, as they were huge, at least 9 feet tall. One held an enormous magical sword that had fallen from Heaven, and the other held a horn, which the warlock claimed was the horn of Merlin.

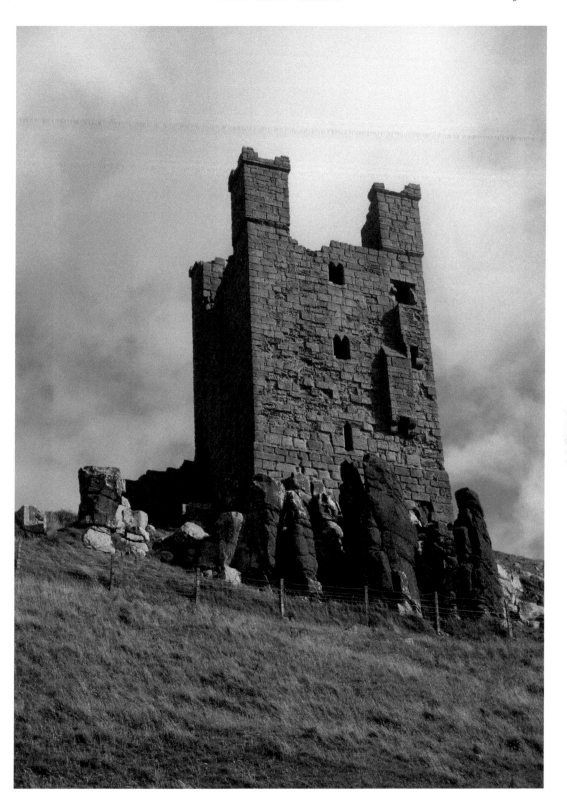

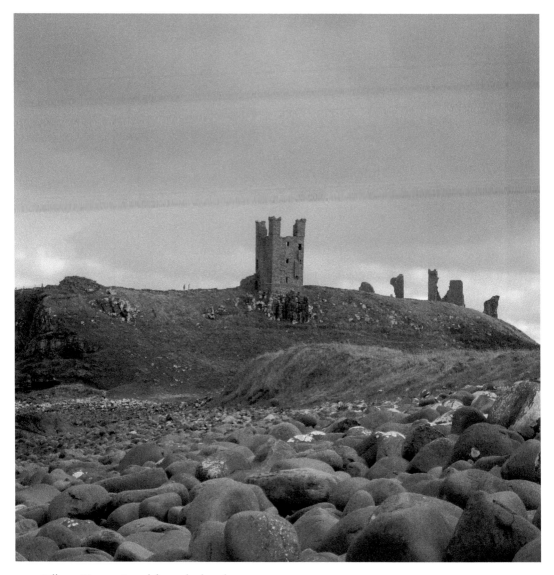

Lilburn Tower viewed from the beach.

'The maid's fate depends on you,' the warlock declared 'Which should you choose to awaken her from her slumber, horn or sword?'

Guy's instinct was to take the sword and kill every single one of these hellish creatures, but he knew that he alone could not defeat them, so he grabbed the horn. The moment he touched the horn the warriors awoke, getting to their feet as one and screaming to the skies above. They saw Sir Guy and charged towards him, swords held aloft. He put the horn to his lips and blew.

The warlock spoke 'shame on the coward who sounded a horn, when he might have unsheathed a sword'. As the skeletal army swung their swords at Sir Guy, a blue vapour surrounded him, and he passed out.

The ruins are extensive.

The next morning he awoke, lying beneath the yew tree that he was stood next to the night before. He assumed it was all a dream, that was until he realised he still held the horn in his hand. He tried desperately to get back into the castle, but there was no way inside. Sir Guy searched, for the rest of his life, for a way into Dunstanburgh Castle to rescue the princess that he failed. When he died he was laid to rest at a nearby church. However, it has been written that even in death Sir Guy has not given up on his quest. A man clad in armour, the sun reflecting from the shiny metal, has been seen, and he is always seen outside the castle.

Battlefields

There's a school of thought that ghosts remain at a location when the person loses their life in a traumatic manner. There's little surprise then, that there are battlefields all over the world, believed to be haunted due to the manner in which countless deaths occurred. Northumberland is no exception, including the site of the bloodiest battle in the history of the country.

Flodden Field

The Battle of Flodden Field, also known as the Battle of Branxton, was fought on 9 September 1513 between King James IV's invading Scots and the defending English

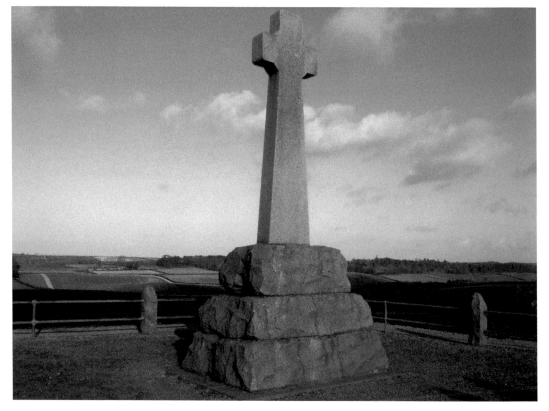

The Flodden Field monument.

army led by Thomas Howard, Earl of Surrey. The previous month, on 22 August, 80,000 Scottish soldiers entered England, crossing the River Tweed at Coldstream. On their way to Flodden, they attacked, and burned, Norham, Ark, and Etal castles. They then took Ford Castle, and occupied it for a number of days, before once again heading south towards the battle.

At the same time the English were heading north and on 3 September they arrived at Alnwick Castle where Thomas Howard, with his army of around 25,000 men, was aided by his sons Thomas and Edmund, and other noblemen.

The weather on 9 September was awful. It was raining heavily and a thick mist hung in the air. The English and the Scots were positioned 1 mile apart. The Scottish forces numbered around 34,000, outnumbering the English's 26,000. The Scots also held the higher ground, and the advantage, due to their position at the top of Branxton Hill, the English at the foot of it. Between them was Branxton Moor, which was a bog due to the persistent heavy rainfall.

At 4 p.m. the sound of gunfire echoed across the usually peaceful Branxton countryside, as both sides opened fire. The English got the better of this initial exchange, as the Scottish gunmen were using bigger, slower, less accurate weapons.

King James IV, looking to give the Scottish an advantage, spotted that the English right wing; men from Lancashire and Cheshire under the command of Lord Edmund Howard looked disorganised and lacking leadership. He called for the Scottish left wing to hit them hard, and they charged down the hill. King James was right, and many of the English men fled, leaving those brave souls who stood their ground to be quickly cut down where they stood. Lord Darce and some English borderers saw the Scottish left breaking through and quickly took up the fight. They soon received added support, when Thomas Howard ordered a cavalry charge to join the attack against the Scottish left wing. With this the Scottish left fell back, and then fled the battle entirely.

King James IV was eager to get involved in the battle and led the Scottish centre charge down the hill towards the English centre. The English centre stood their ground as the Scots neared, despite the scene of the Scots charging down the hill towards them, weapons raised to the skies. The Scottish would have unquestionably won this exchange, and ultimately the battle, but the weather proved to be the Scot's undoing. The Scottish were charging at full speed when they reached the foot of the hill, but then they reached marshy, boggy ground, which proved difficult to cross. They were also mostly armed with 18-foot-long pikes, which were heavy and unwieldy and designed for combat against cavalry. The English seized the initiative, armed with billhooks, and could simply cut the heads off the Scottish pikes, leaving them with nothing more than a long wooden pole, effectively unarmed and defenseless. The Scottish were hacked to pieces, and with this central column of soldiers defeated, the remainder of the Scottish army were vastly outnumbered, outmaneuvered, and facing certain death. Many fled, but those who remained surrounded their king, before they too joined the thousands of corpses on the battlefield. King James IV was the last monarch of Great Britain to be killed in battle.

The Battle of Flodden Field was the bloodiest battle ever in the history of England, with up to 14,000 killed in only three hours.

The following morning the battlefield was looted by Border Reivers. They removed anything of value from the bodies that lay everywhere, and a lot of weaponry.

Above and below: These empty, quiet fields were the site where up to 14,000 people died that day.

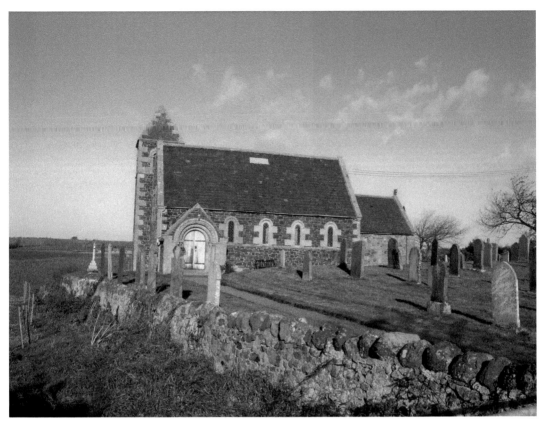

St Paul's Church in Branxton. The bodies of men killed that day are in a pit within the churchyard.

The bodies of the dead were thrown into two large pits. Most of the bodies were thrown into a deep pit at the battlefield, and the remaining thrown in a pit in the churchyard in Branxton.

The body of King James IV is said to have been buried at Lanercost Priory in Brampton, Cumbria. However, there have been suggestions ever since the battle that his corpse was disemboweled and sent to the Monastery of Sheen in Richmond, London. His head is said to have been cut off and used as a macabre plaything, and was passed from one English noble to another, before eventually being buried in an unmarked grave.

Such a staggering loss of life, in only a few hours, combined with the majority of these bodies being dumped into a pit beneath the ground here, seems to have left its mark on Flodden Field as this is believed to be a very haunted location today.

The most commonly experienced phenomenon is the ghostly recreation of the battle. The first documented occurrence of this was in the 1700s when two brothers swore that they saw the entire battle being refought. When questioned about it afterwards they could describe precisely every detail of the conflict. They could describe accurately what people looked like and what was on their banners.

Those who haven't seen this spectral recreation have heard it, the sound of the cries of battle, the clash of swords, and the groans and screams of death.

Phantom soldiers have been seen crossing this stretch of road.

The A697 nearby has been the location of sightings of phantom soldiers crossing the road on their way to the Battle of Flodden.

Otterburn Battlefield

The Battle of Otterburn, also known as the Chevy Chase, took place on 19 August 1388 (although Scottish sources document it as 5 August). It was fought on a stretch of land between the A696 and Otterburn Hall. The Scottish were led south by James, 2nd Earl of Douglas. The army of English defenders were led by the Northumbrian hero Henry Percy, 1st Earl of Northumberland, who was nicknamed Hotspur, a name given to him by the Scots as a tribute to his speed in advance and readiness to attack.

The Scottish noble James, 2nd Earl of Douglas, led a raid south, into English territory, and specifically the remote countryside around Newcastle and Durham. Henry Percy gave chase, but James had anticipated this and retreated north, but only as far as Otterburn, where he waited. He knew they would be well rested when the English arrived.

Percy pushed his troops hard on their ride to Otterburn. When he arrived, he was so confident, especially given his army outnumbered the Scots by three to one, that, despite his men being in desperate need of rest, he attacked the Scots before all of

Otterburn Battlefield Monument.

his army had even reached Otterburn. The English were disorganised, and the much smaller Scottish force won the battle with ease.

Henry Percy tried to flee, realising the battle was lost, but was captured by Sir John Montgomery, 9th Lord of Eaglesham, and later ransomed. Montgomery used the money to build Polnoon Castle. The English survivors who fled made it as far as the Elsdon moors but the majority were rounded up and taken prisoner.

That day around 1860 Englishmen were killed, with around 1,040 being captured, while around 100 Scots were killed. The battle may have been over quickly, but some claim that over 600 years later, they see the battle still being fought on that small strip of land in Otterburn.

The earliest recorded sighting of the ghostly replay of the Battle of Otterburn was in 1888, when two shepherds named Percival Hall and John Ellesden were driving their sheep just as darkness set in. They were both startled by the sound of galloping horses. They looked around but saw nothing, despite the sound getting louder and the horses getting closer. They then heard the sound of trumpets. Still they saw nothing.

Looking to a ridge overhead Hall claimed to see the spectral figures of men fighting and men dying. They both heard the sounds of battle, the screams of the dying, the sound of sword striking sword. Then as suddenly as it began, it just stopped, and they were once again alone.

Above and below: The battle was fought on this very land.

In the 1960s a taxi driver was driving through the area of the battle when his taxi suddenly stopped. He tried to start the engine, but it was dead. He noticed that despite not moving, the fare meter was increasing, slowly at first, then rapidly, amassing a huge amount of money. He looked out of his windscreen and saw soldiers, clutching swords, approaching his taxi. He tried the engine again, but it was dead. Then the soldiers were gone, just vanished. He was able to start the taxi at the first attempt, and the fare meter had returned to the fare it had displayed before the terrifying encounter.

About the Author

Rob Kirkup was born in Ashington, Northumberland, and has lived in the North East all of his life. He developed a keen interest in myths, legends, the paranormal, and all things considered supernatural or otherworldly from an early age, amassing a large collection of books and newspaper cuttings on the subject, and in particular tales based in his native north-east of England.

Rob had his first book published in 2008 and has since written a number of books focussing on different aspects of the history of Northumberland, Tyne and Wear, County Durham, Cumbria, York and Edinburgh.

In 2022 Rob started his podcast 'How Haunted?', with each episode looking at the history and ghost stories of one of the most haunted locations in the world. It has proven very popular and is available everywhere you would usually find your podcasts, including Spotify, Apple Podcasts, Google Podcasts, and Alexa-enabled devices.

The author.